RIVER CLYDE

Richard Happer & Mark Steward

AMBERLEY

First published 2014

Amberley Publishing
The Hill, Stroud, Gloucestershire, GL5 4EP
www.amberley-books.com

Copyright © Richard Happer & Mark Steward, 2014

The right of Richard Happer & Mark Steward to be identified as the
Authors of this work has been asserted in accordance with the
Copyrights, Designs and Patents Act 1988.

ISBN 978 1 4456 4311 3 (print)
ISBN 978 1 4456 4327 4 (ebook)

All rights reserved. No part of this book may be reprinted or reproduced or utilised in any
form or by any electronic, mechanical or other means, now known or hereafter invented,
including photocopying and recording, or in any information storage or retrieval system,
without the permission in writing from the Publishers.

British Library Cataloguing in Publication Data.
A catalogue record for this book is available from the British Library.

Typesetting by Amberley Publishing.
Printed in Great Britain.

CONTENTS

	Foreword	4
	Acknowledgements	5
1	The River of Gold	6
2	Westward Ho	25
3	New Lanark	42
4	From Country to City	58
5	Glasgow East & Central	88
6	Glasgow West	115
7	'Doon the watter'	133

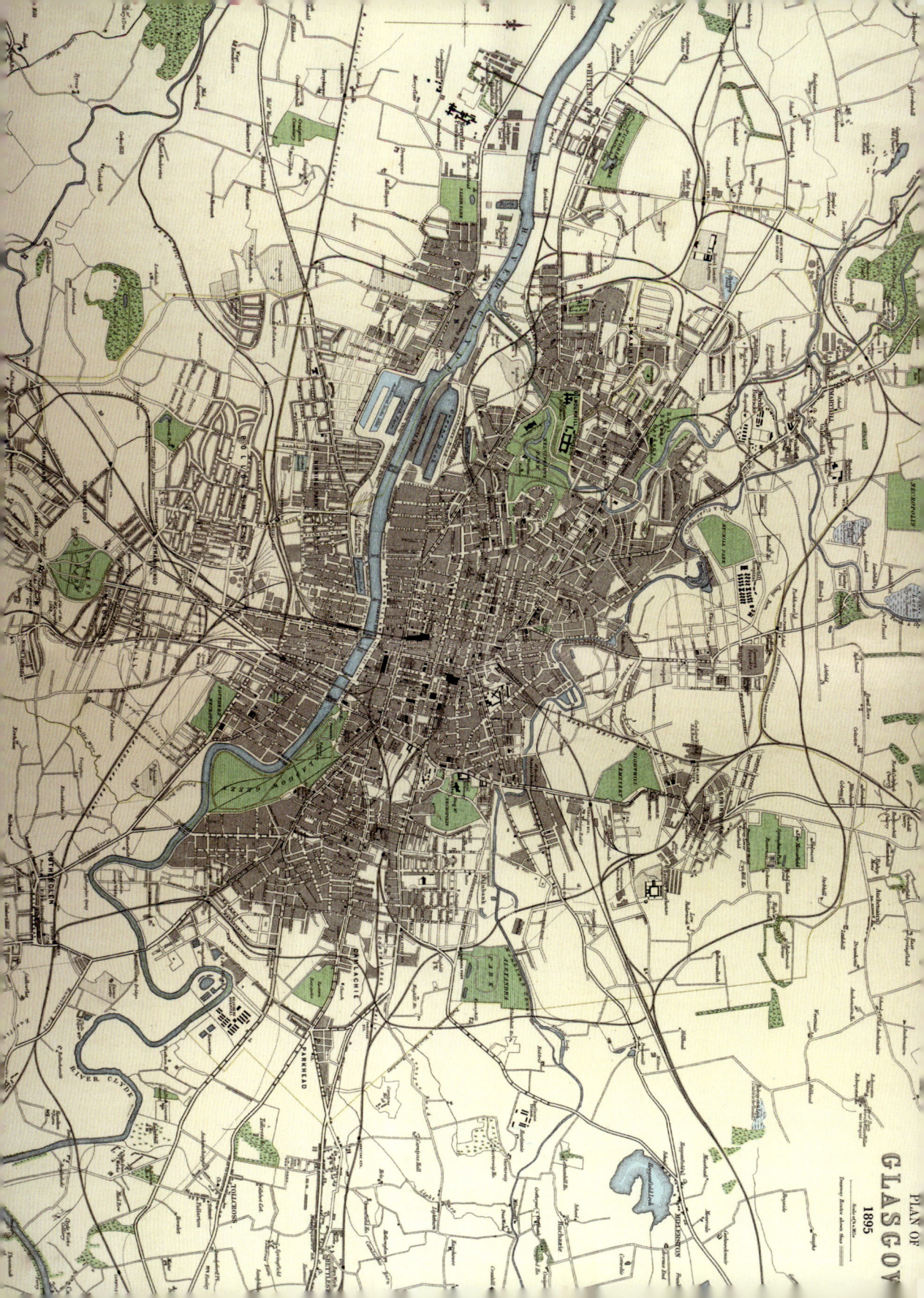

ACKNOWLEDGEMENTS

Text by Richard Happer. Photographs by Richard Happer and Mark Steward, except for the following: p. 85 & p. 86 © Tunnocks; p. 93 photo by Flickr user Dave 602, used under Creative Commons Licence 2.0; p. 124 photo by Flickr user easylocum, used under Creative Commons Licence 2.0; p. 125 Robert Orr; p.135 Stewart Priest; p. 136 painting is in the public domain, image created and licensed by Flickr user mbell1975; p. 139 Graeme Law. Photographs on p. 142 by Harry Happer and p.144 by James Steward.

The authors would like to thank Marg Patterson and all at Tunnocks for their help. We are also grateful to Mark Happer for information about New Lanark.

1

THE CLYDE'S SOURCE IN RICH MINING COUNTRY

Two tumbling streams vie for the honour of the title of 'source of the Clyde': the Daer Water and the Potrail Water, both of which rise in the Lowther Hills of South Lanarkshire. According to the Ordnance Survey, the Clyde begins at the meeting point, but it's worth exploring the hills and cleuchs (small, narrow glens) of the spindly headwaters to get to know the true character of its birthplace. This is a quiet, remote world of scattered farms, hills and rough moorland. The only man-made structures in many valleys are tumbledown stone sheepfolds, often called *shiels* or *shielings* in the Borders (hence 'Galashiels'). It presents such a vivid contrast with the thrumming industrial powerhouse that the river becomes a mere 160 km (100 miles) away.

The land above ground can be bleak and unforgiving here, but under the surface this is as rich and fertile country. Vast amounts of sediment were laid down 500–435 million years ago, when Scotland and England were on separate land masses drifting in an equatorial sea. These masses eventually crunched together, buckling the sea floor upwards to form what is now the Southern Uplands. Volcanoes and ice ages also shaped the landscape, resulting in seams of precious minerals lying near the surface.

Lead, zinc, copper and silver were mined all over these hills, as well as some of the world's purest gold at 22.8 carats (24 carat is as fine as you can get), which was used to make the Scottish Crown.

Pub quiz time. Where is Scotland's highest pub? Aviemore? Glencoe? Somewhere way up near Ullapool? Actually, it's in Wanlockhead in Dumfries & Galloway. Lying just over the back of Lowther Hill from the Potrail Water, this is Scotland's highest village at 467 m (1,531 ft) and it was a thriving mining community until the 1950s.

The Romans were the first to mine the valuable minerals here. More workings sprang up from the thirteenth century and people began to call it 'God's treasure house'. It was actually the Duke of Buccleuch's make in these parts). The Duke built a lead smelting plant and cottages for the workers in 1680.

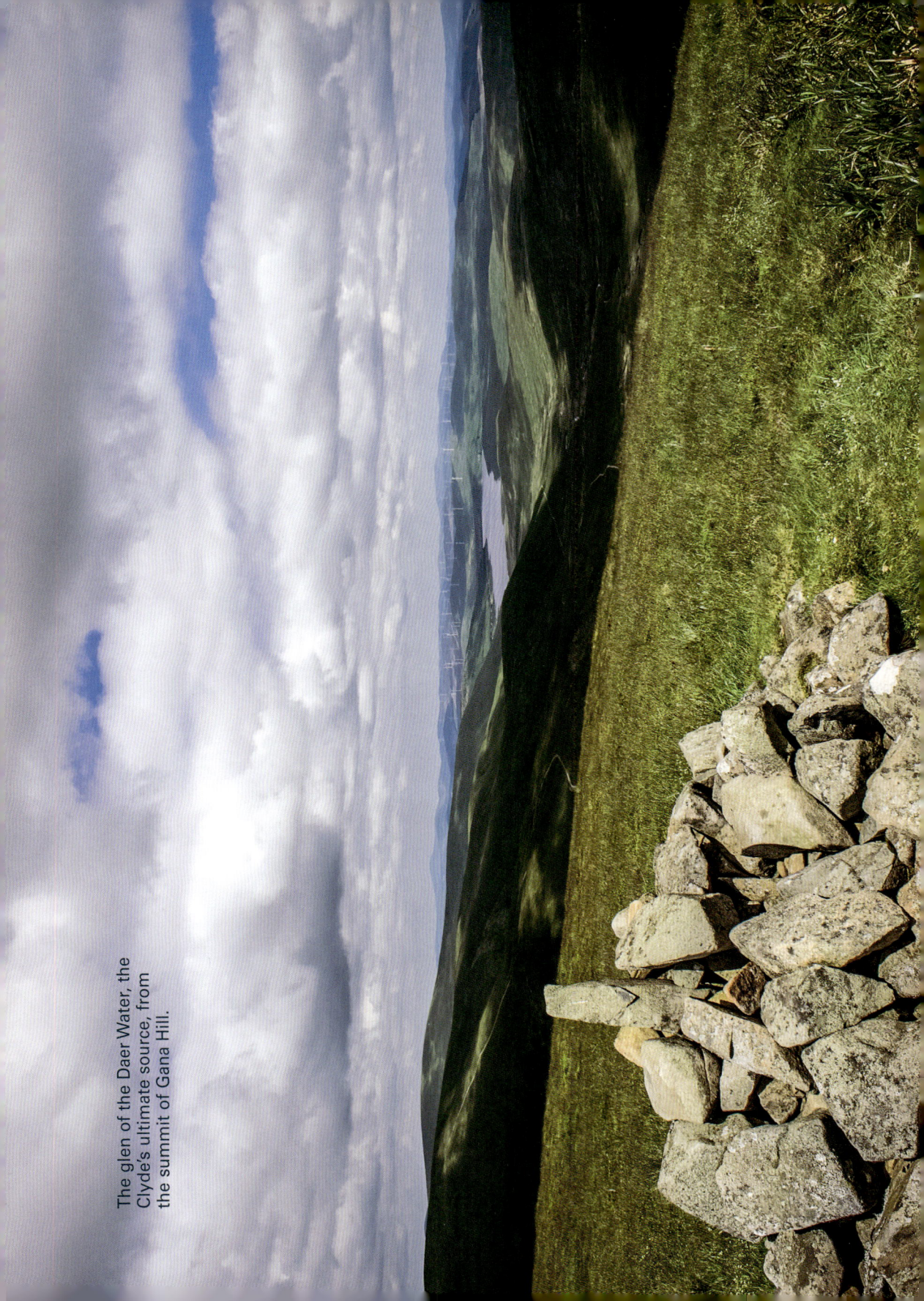

The glen of the Daer Water, the Clyde's ultimate source, from the summit of Gana Hill.

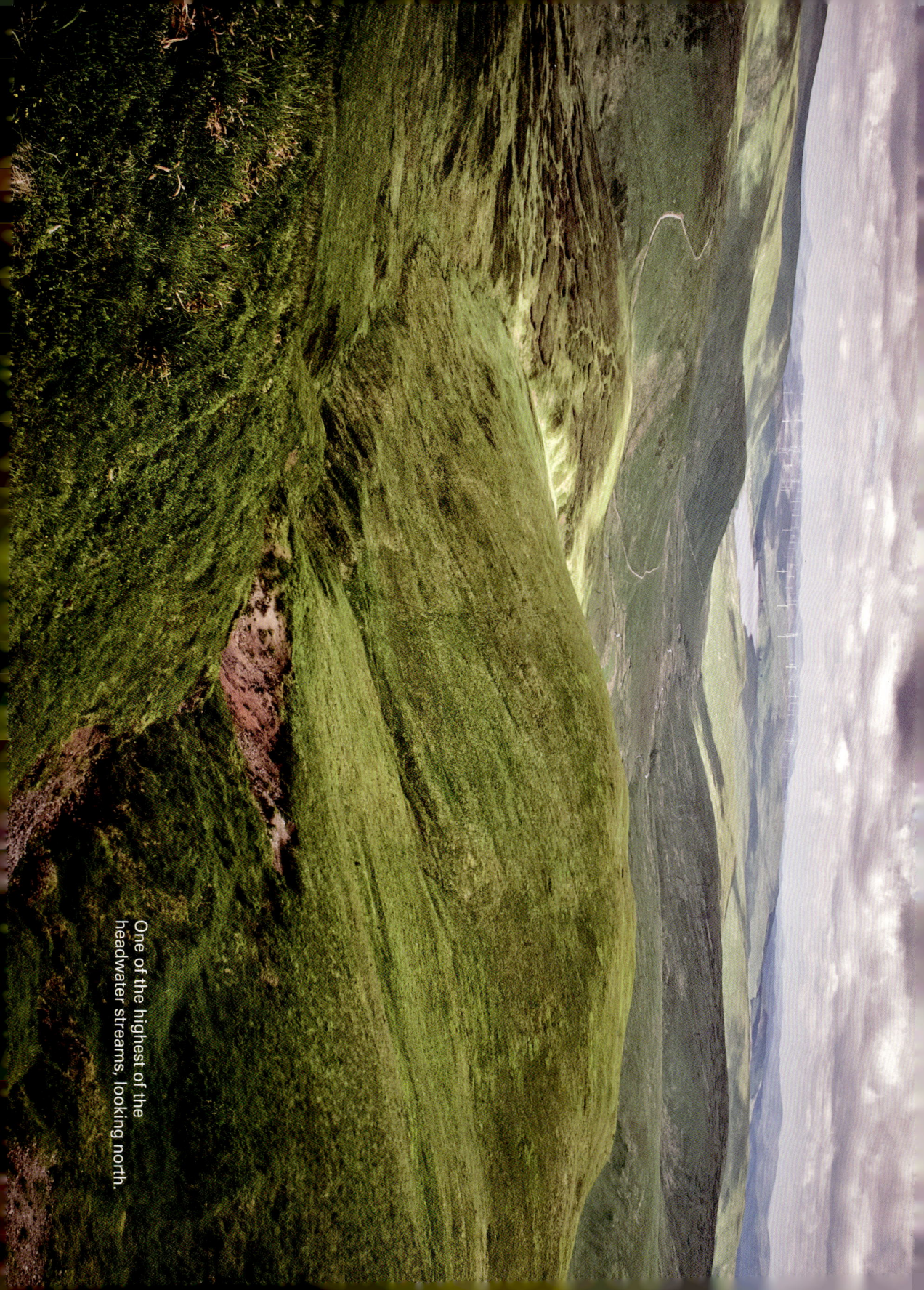

One of the highest of the headwater streams, looking north.

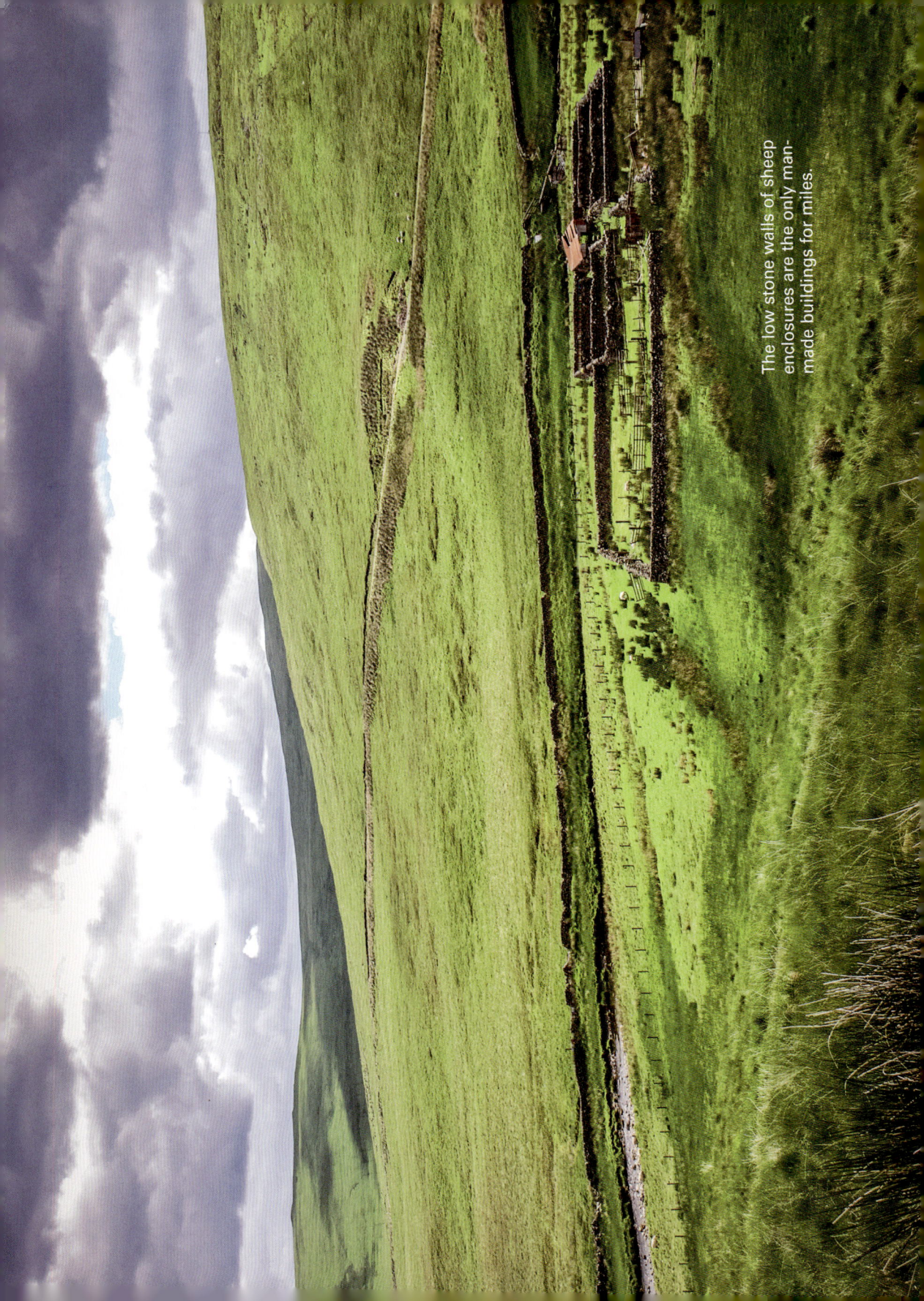

The low stone walls of sheep enclosures are the only man-made buildings for miles.

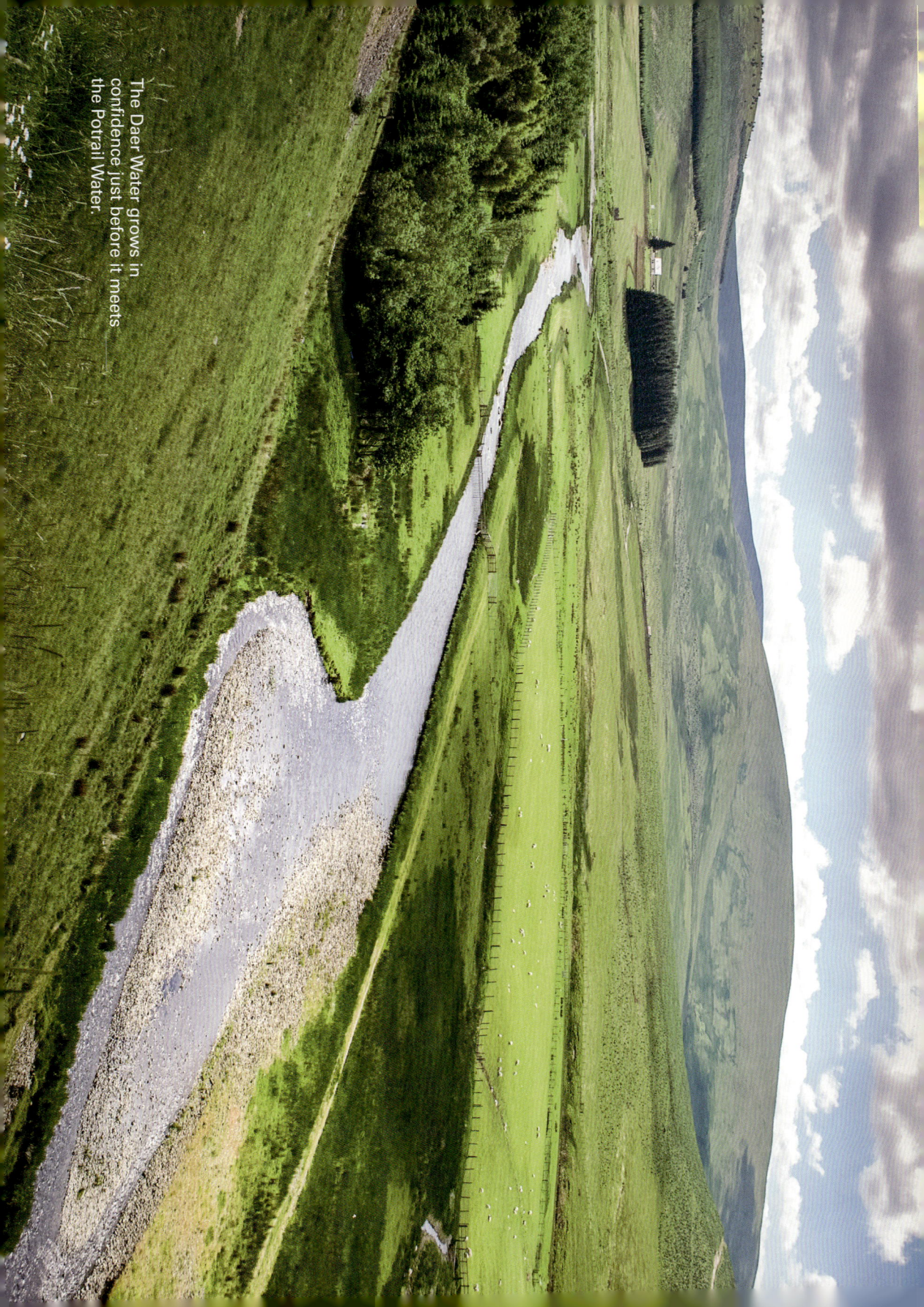

The Daer Water grows in confidence just before it meets the Potrail Water.

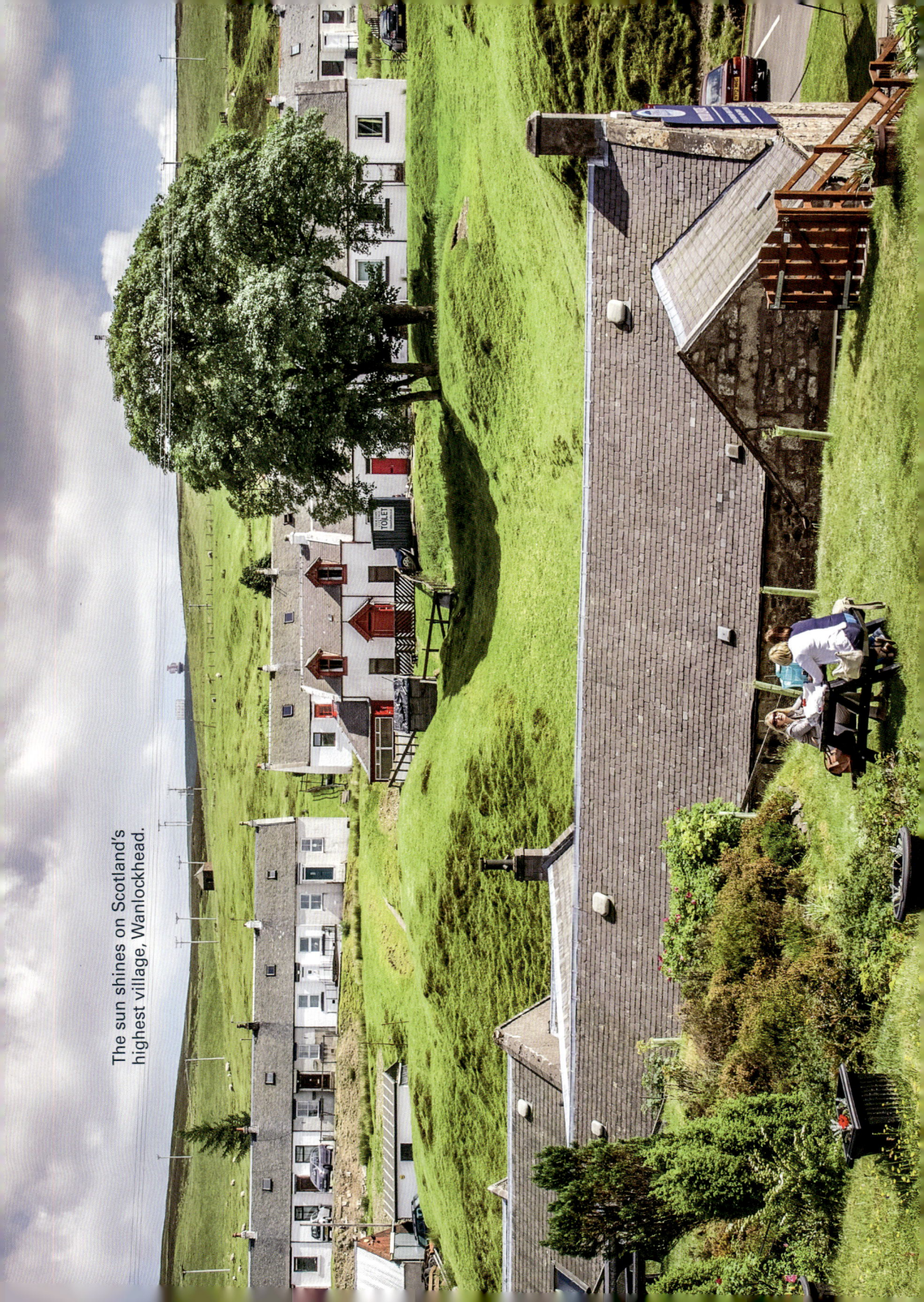
The sun shines on Scotland's highest village, Wanlockhead.

To give the poor miners some form of recreation and education, in 1756, the Duke established the Wanlockhead Miners' Library. This is the second-oldest subscription library in Europe. The oldest lies 2 km away in the neighbouring mining village; the Leadhills Miners' Library was founded in 1741. Leadhills is the birthplace of the poet Allan Ramsay, and the engineer William Symington, who designed the engine on the world's first steamboat in 1788. Leadhills is also home to Scotland's highest, and very possibly windiest, golf course. Bring old balls.

Pop into the Wanlockhead mining museum and you can see the kind of life miners led (dirty and short) and try panning for gold. There's still plenty in them thar hills – the British gold panning championships are frequently held here. You can also see the Wanlockhead Beam Engine, which was built in the mid-nineteenth century to pump water from the mines, and is a very rare example of its type.

There are several old mine entrances dotted around the town, which look a little bit like hobbit holes. Inside, however, they are far from being as pleasant as Bilbo's home. These really were nasty, grubby little wormings in the earth. One of the mineshafts was sunk 460 m, delving more than 120 m below sea level.

Wanlockhead also has a short stretch of narrow gauge railway, lovingly maintained by several enthusiastic blokes in boiler suits. Originally, this was a standard-gauge track, the highest in Britain, which joined the mainline at Elvanfoot. It was used to take lead and other metals to Edinburgh, saving horses the two-day journey.

At 792 m (2,600 ft) long and 41 m (135 ft) high, the dam built for the Daer Water Reservoir was the largest of its kind in Britain when the Queen opened it in 1956. It supplies 20 million gallons of drinking water a day to the central belt. An osprey can sometimes be seen here, showing the anglers how fishing should be done.

CLYDESDALE

Dozens of streamlets scramble down these hillsides to join the young Clyde as it marches along the flat valley floor. By Elvanfoot the Clyde looks very much like a proper river, and it picks up pace and volume as it rolls from side to side between rounded hills.

It is just one of many travellers here, with the A702, M74 and West Coast Mainline all jostling for position in the pass. The Romans built the first trunk road here almost two millennia ago. Their route went all the way to Musselburgh and you can still walk on several sections of it, particularly south of Crawford.

For centuries this was also a pilgrim trail. Thousands of worshippers plodded south from Edinburgh over the on their way to Whithorn, home of Scotland's first Christian church, which was built by Saint Ninian around AD 397. 'Clydesdale' first appears on the map just north of Glenochar, 1 km from the meeting of the Daer and Potrail

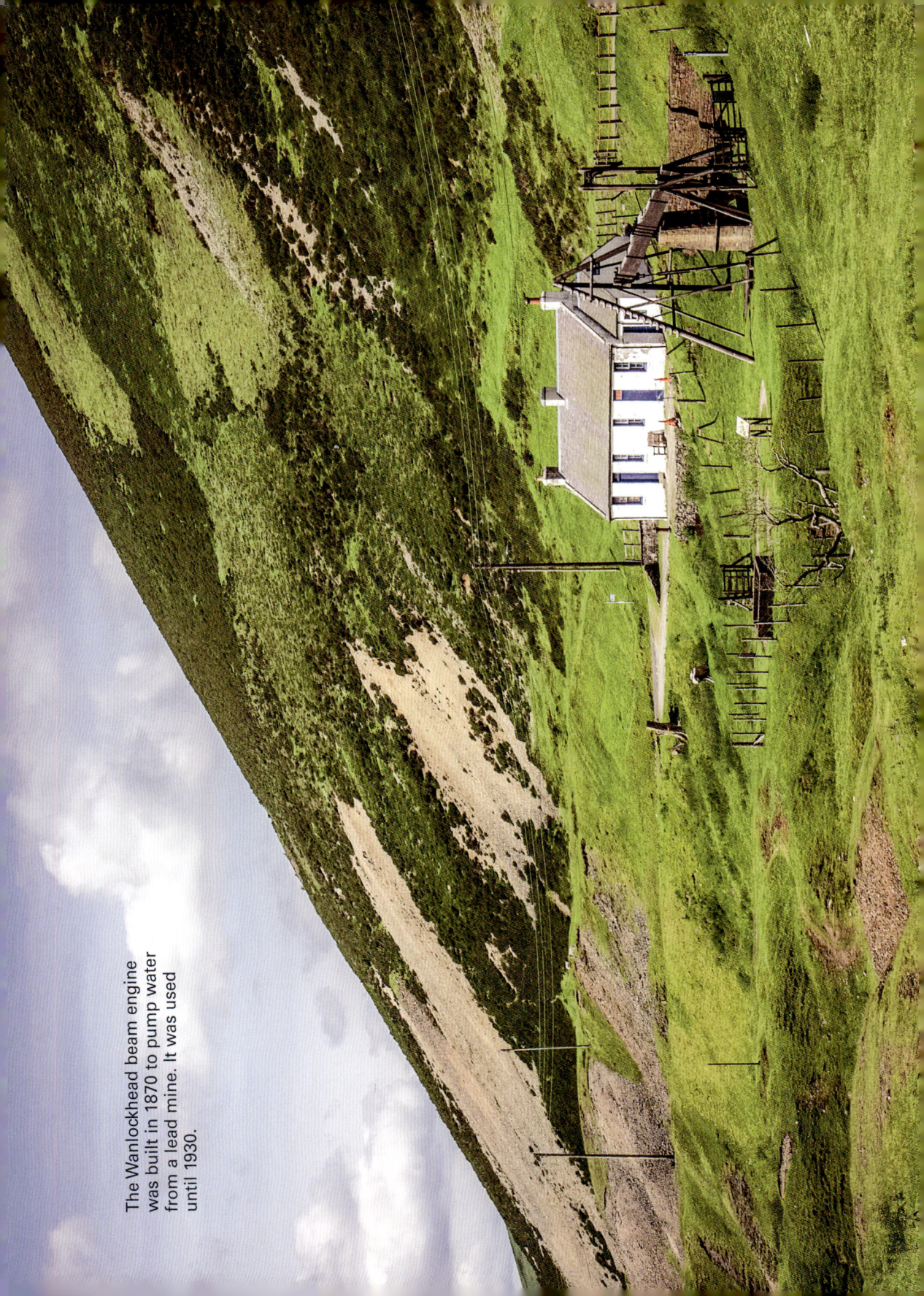

The Wanlockhead beam engine was built in 1870 to pump water from a lead mine. It was used until 1930.

This door in the hillside is one of many mine entrances still visible.

waters. It is in this farmland that the hardy Clydesdale horse was bred. In the late nineteenth and early twentieth centuries, thousands of Clydesdales were exported from Scotland and sent throughout the world, including to Australia and New Zealand, where they became known as 'the breed that built Australia'.

The village of Crawford is close to the old Roman road and there was a Roman fort here that housed 300 soldiers around AD 100. Around 1175, the Crawford family held the local barony and built a castle at this strategically important point on the route into England from the Clyde valley. William Wallace is said to have laid waste to it in 1297, and he did tend to do a lot of that sort of thing so it's quite likely. He left a few bits standing, and you can still see them today on the north bank of the Clyde.

THE BLOODY BORDERLANDS

You pull off the M74 at Abington, grab a Costa Coffee, get a paper in WHSmith, gaze at the hills for a bit then drive on, reaching Glasgow or Edinburgh within the hour. Travelling here really is so easy now, but centuries ago this would have been a frightening place to journey through – and to live in.

The moors and hills made arable farming difficult, and men made it even harder. In the late Middle Ages, Scotland and England were more often at war than not, and the border lands saw a lot of action every time an army of either side came rampaging through. There were

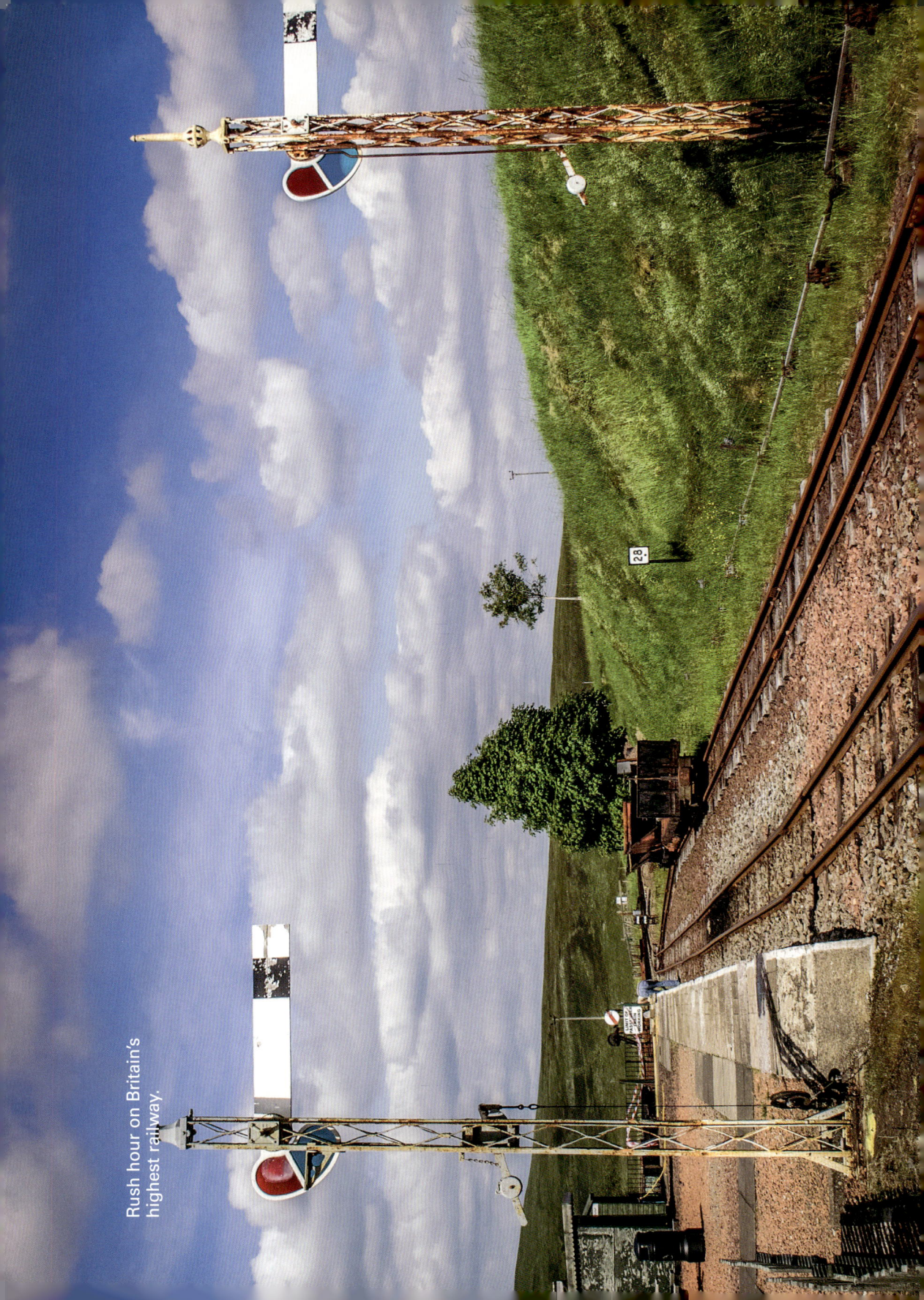

Rush hour on Britain's highest railway.

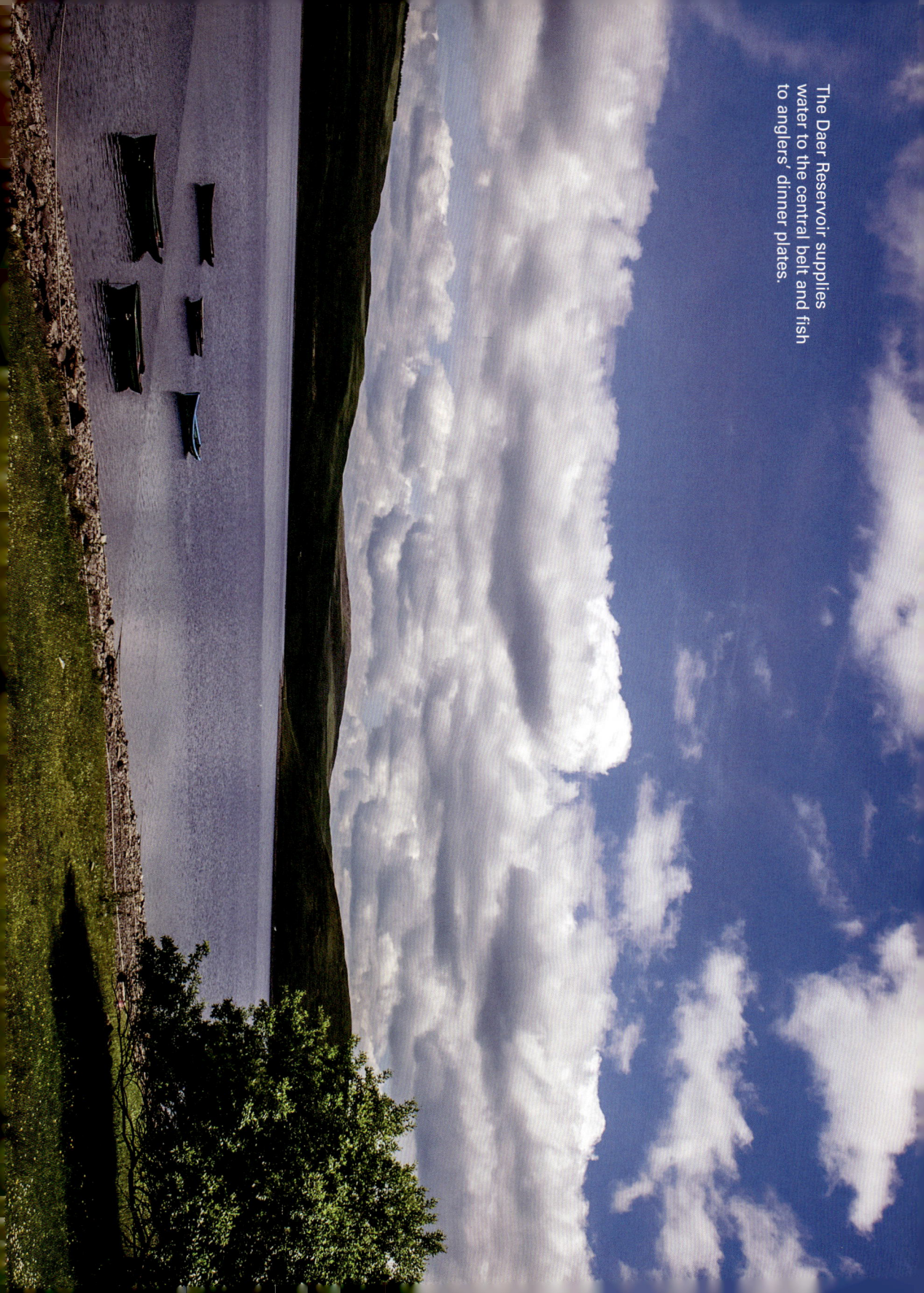

The Daer Reservoir supplies water to the central belt and fish to anglers' dinner plates.

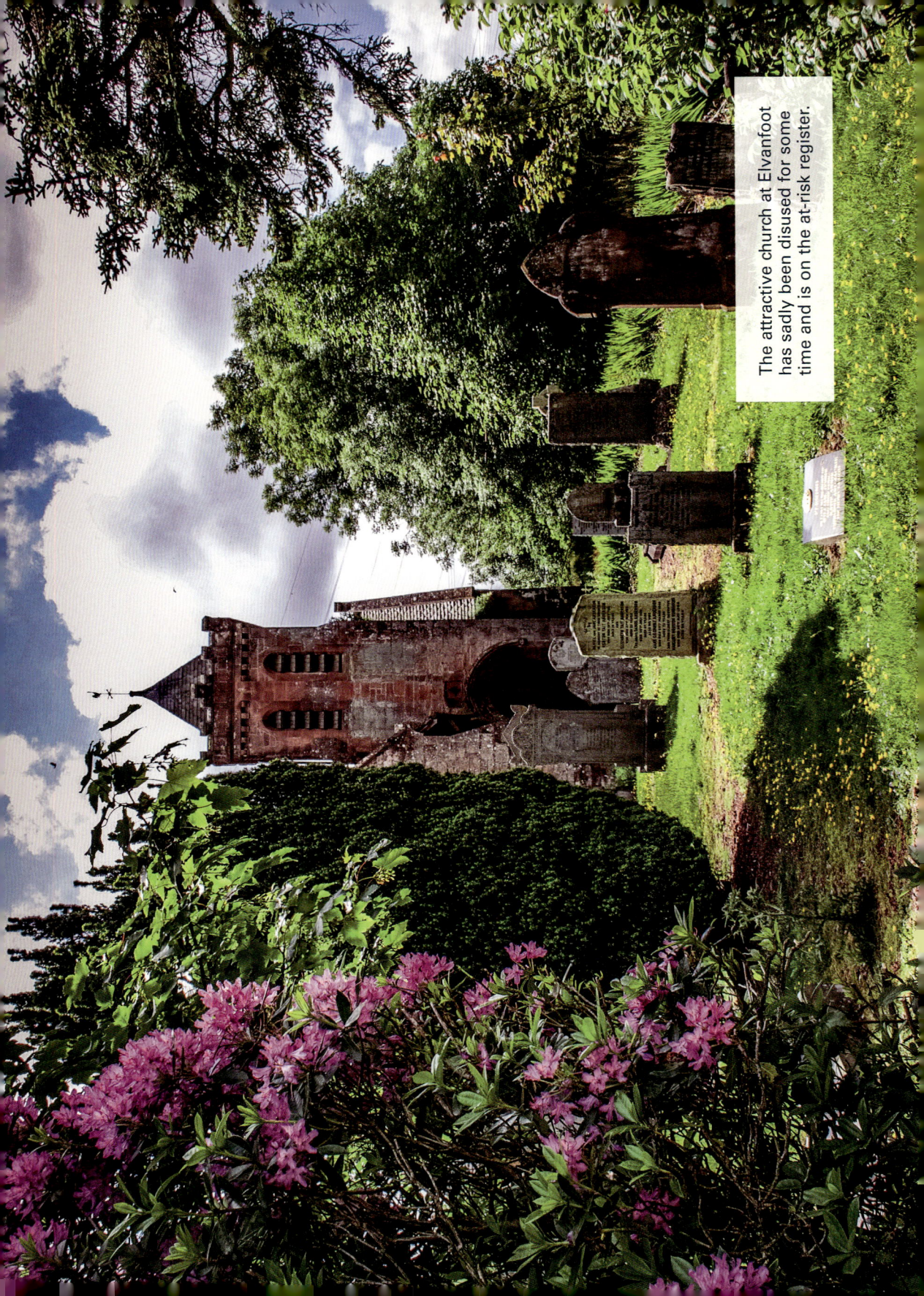

The attractive church at Elvanfoot has sadly been disused for some time and is on the at-risk register.

also the Border Reivers, gangs of riders from both sides of the border, who stole animals and goods from anyone without a powerful protector. (Think McCorleone and you're not far off.) The terrain naturally lends itself to cattle rustling; there are lots of little cleuchs hidden behind big hill. Gangs of riders, up to 3,000 strong, would range as far as Edinburgh and Yorkshire, pilfering and terrorising wherever they went. What with religious wars and blood feuds lasting generations, this was as unsettled and vicious as many modern conflict zones.

It's no wonder that ordinary farmers built bastles. These fortified farmhouses had few windows, with many just arrow slits, and walls around 4 ft thick. Animals were kept on the ground floor, with families living on a higher level above. Access was often by ladder. There are several bastles still remaining, many of which are marked on the OS map. It's worth turning off the motorway and taking an hour or two to get a little insight into how hard life could be not so very far from home, nor so very long ago.

WALK 1
SOURCE OF THE CLYDE
DISTANCE: 12 KM
TIME: 4 HOURS

The Clyde doesn't give up the secrets of its source easily. Pull on your boots, pack a Tunnocks caramel wafer in your knapsack and after a couple of hours of fine walking you can track it down however. Drive south from Elvanfoot on the A702 and turn left just after Glenochar. You'll immediately cross over two little rivers, the Potrail and the Daer – the first of the seventy-two bridges that take people, trains, cars and sheep across the Clyde.

Now look to your left. 500 m away, where those cows are sitting down, is Watermeetings, the official source of the Clyde. But we're going to find the ultimate headwater, so drive on for 4 km and turn right before you reach the waterworks below the Daer Reservoir dam. Another 5 km further on, park off the road near Kirkhope Farm. Walk through the farmyard and head south on the Land Rover track that follows the Daer Water. When you reach 'Thick Cleuch' on the map (OS grid ref 958024), leave the path and strike straight up through the heather for the summit of Gana Hill. From here you'll get a terrific view of the Lowther hills, home of the Clyde's myriad source streams, as well as the hills of Dumfries and Galloway to the far south-west.

On the way back, your intrepid authors stopped at a burn to quench their thirsts and were able to say that they had 'drunk the Clyde'. You will be pleased to hear it is delicious.

Note: if you fancy a longer wander, just before the Daer and Potrail meet you can head off on the Southern Upland Way, a magnificent 212 mile (341 km) coast-to-coast walk.

THE RIVER OF GOLD 19

Clydesdale horses are usually a bit hairier than this well-behaved fellow.

THE WANLOCKHEAD INN
BAR MEALS
Highest Pub in Scotland

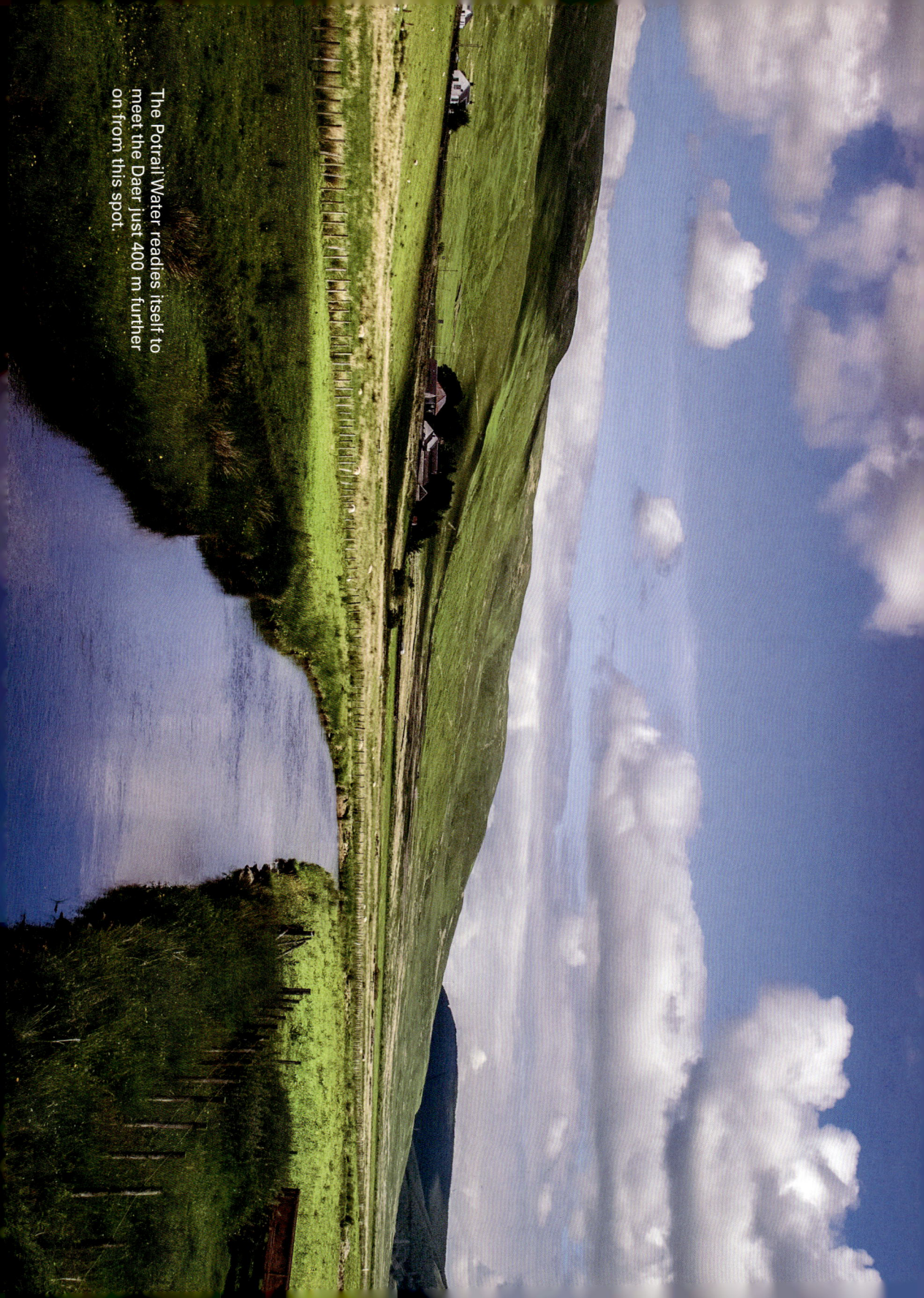

The Potrail Water readies itself to meet the Daer just 400 m further on from this spot.

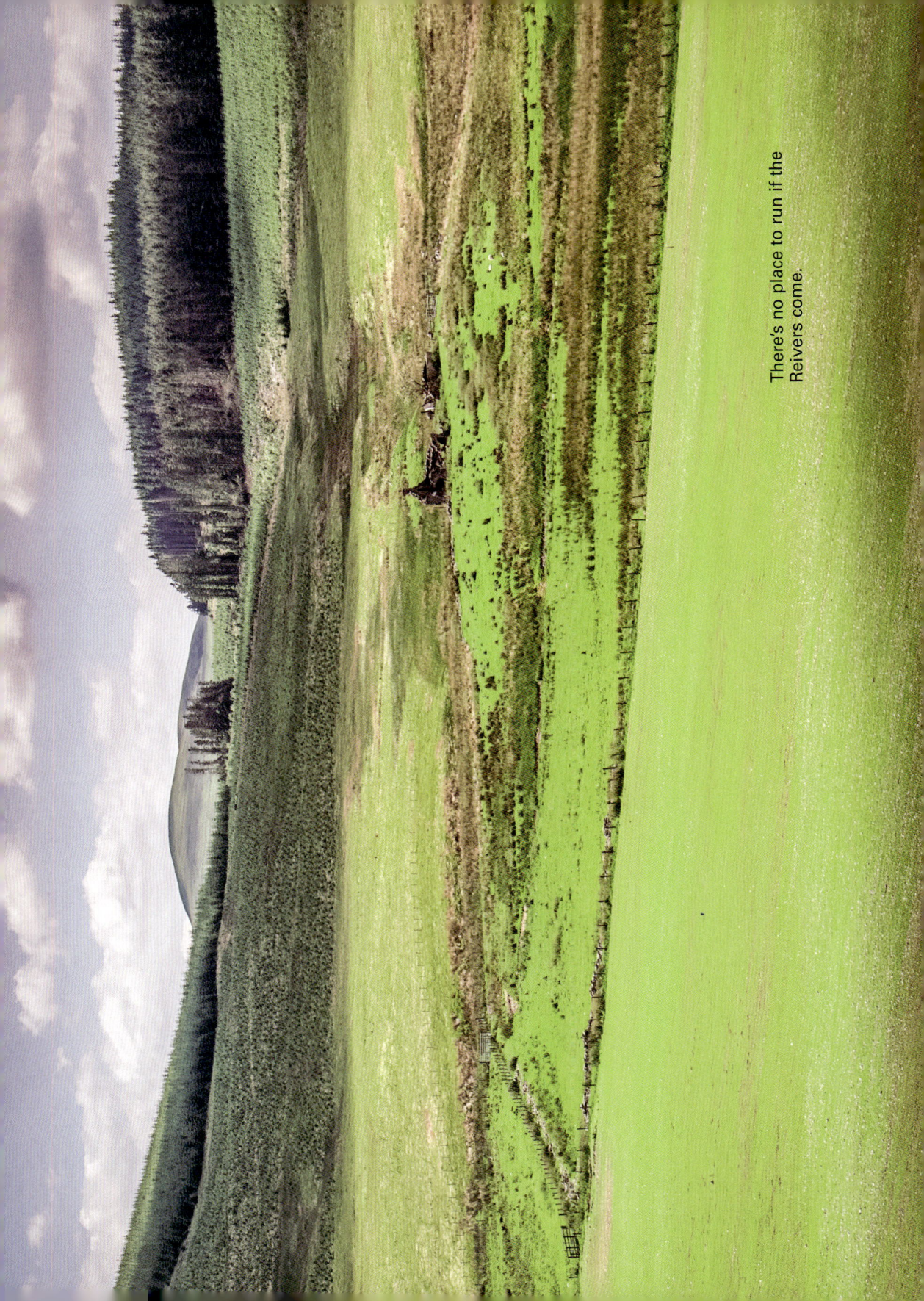

There's no place to run if the Reivers come.

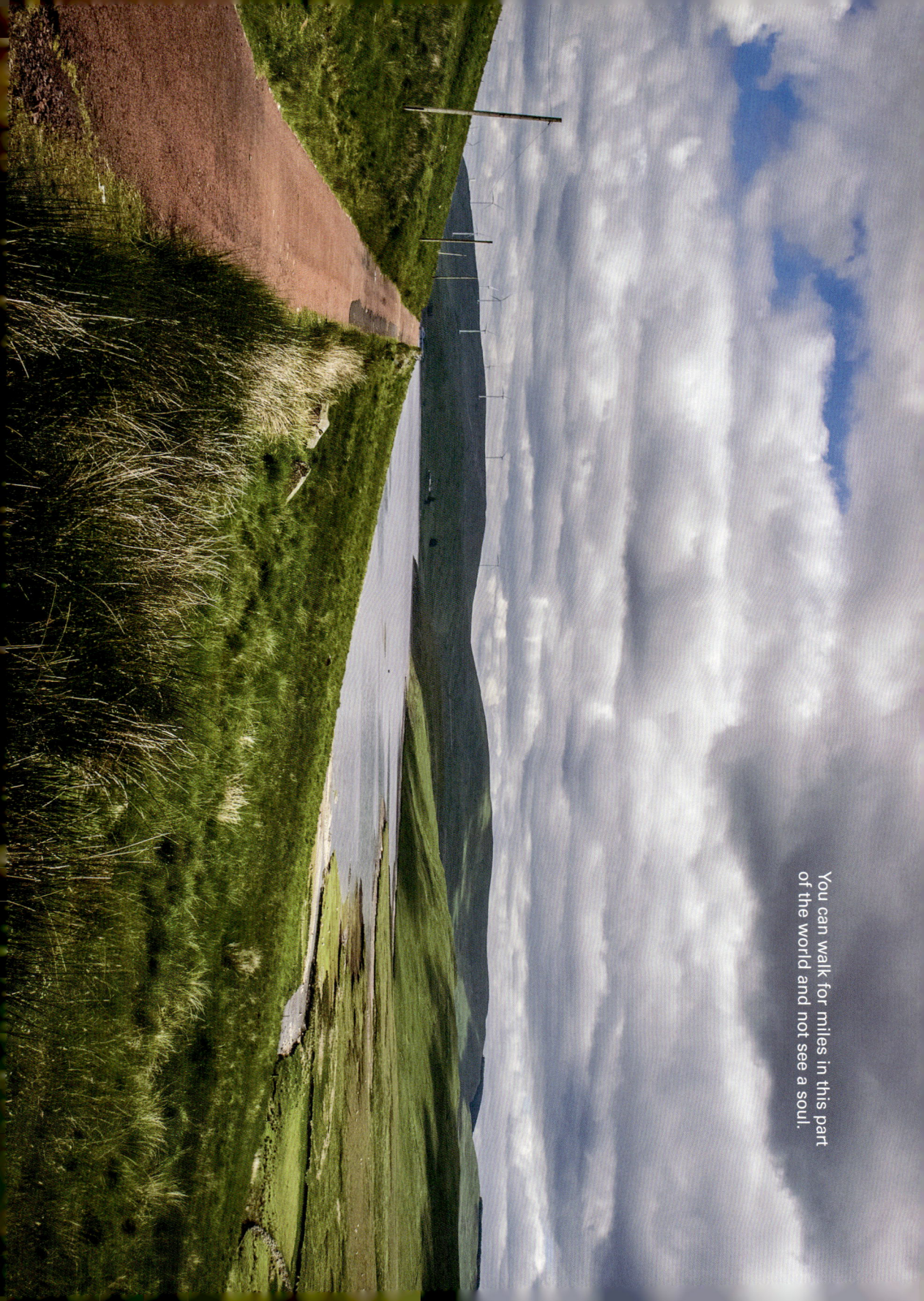

You can walk for miles in this part of the world and not see a soul.

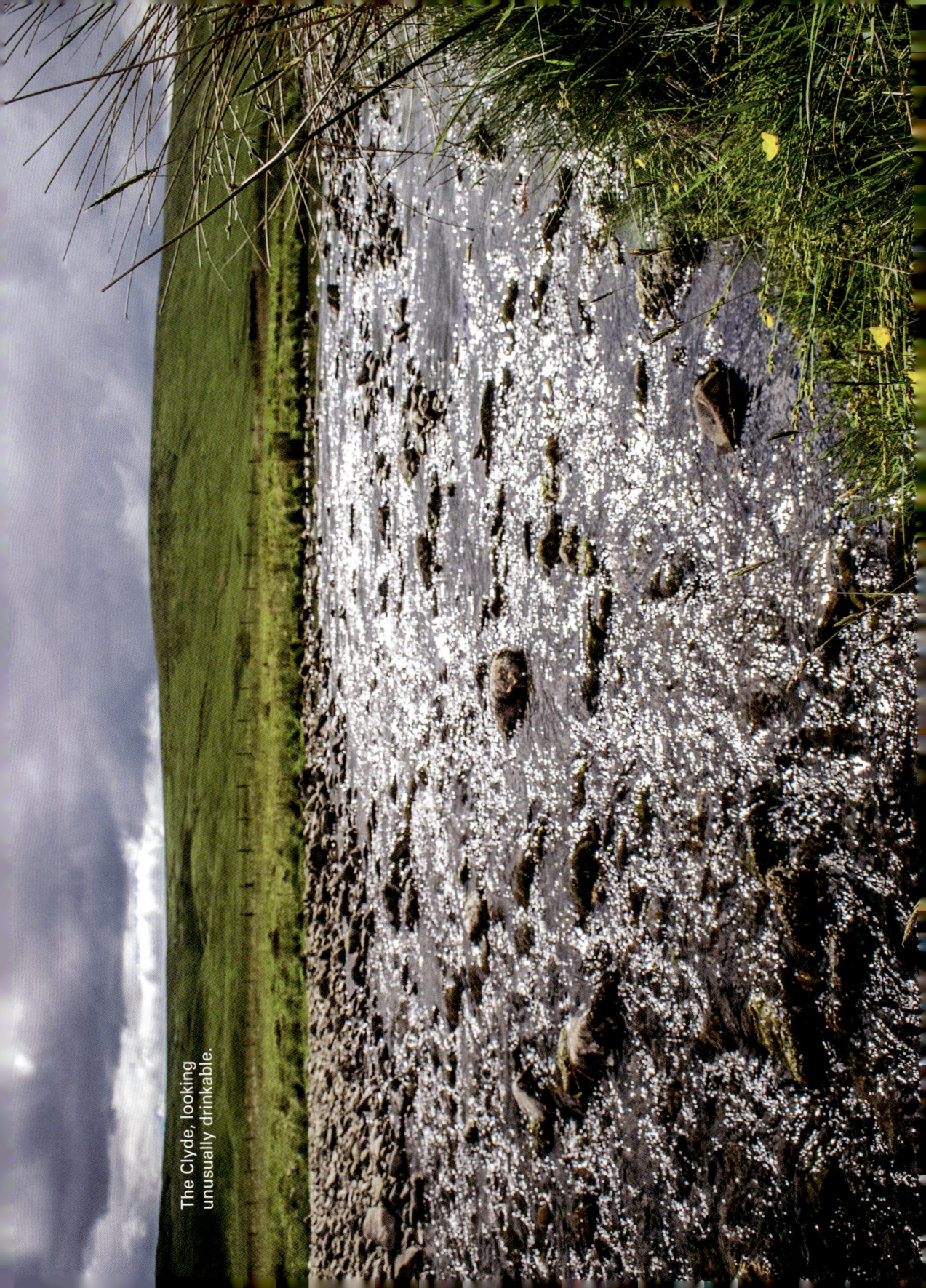

The Clyde, looking unusually drinkable.

Coast to coast in 16 days – there may be no Munros, but there are 80 summits over 2,000 ft (610 m).

2

WESTWARD HO

BIGGAR TO THE FALLS OF CLYDE

The Clyde starts its life flowing in a totally different direction to its ultimate orientation. Until now it has generally been heading north, and as it nears the town of Biggar it is actually flowing northeast towards Edinburgh. But, like a 3 a.m. wanderer on Sauchiehall Street, it suddenly seems to think better of its plan and veers violently sideways round Tinto Hill, taking aim on Hope Street. Well, Glasgow.

There's a good geological reason for this; before a vast ice sheet covered the whole of Scotland around 10,000–11,000 years ago, most of the tributaries of today's upper Clyde then flowed into the River Tweed. Another great river, this runs east through the Borders to reach the North Sea at Berwick-upon-Tweed. The watershed between the two rivers was near present-day Lanark. When the ice melted though, the Clyde gained enough erosive power to cut its way back and 'capture' several streams from the Tweed. These tributaries, with their extended catchment areas, made the Clyde the size it is today.

Even now, if the land just south of Biggar were 3 m (10 ft) lower, the Clyde would continue east and join with the Biggar Water, a tributary of the Tweed just over the watershed. Our civilisation is very glad that isn't the case.

TINTO HILL

Tinto is something of a lost sheep in the border hills; the Clyde cuts it off from its brethren in the Southern Uplands. This prominence means the views from its 707 m (2320 ft) summit are splendid in every direction. On a very clear day you can see the Lake District, Arran in the Firth of Clyde, the mountains of Mourne in Northern Ireland, the Arrochar Alps and even Lochnagar in the far north (although you'll need Steve Austin's bionic eye to spot that summit). The summit cairn was begun in the Bronze Age and is the largest in Scotland at 4 m (13 ft) tall.

The hill itself is a vast belch of reddish igneous rock produced from the earth's innards. This hue can be seen on the exposed upper slopes. The hill has an ancient fort, thanks to its strategic position on the main north–south route for the Romans and even older peoples.

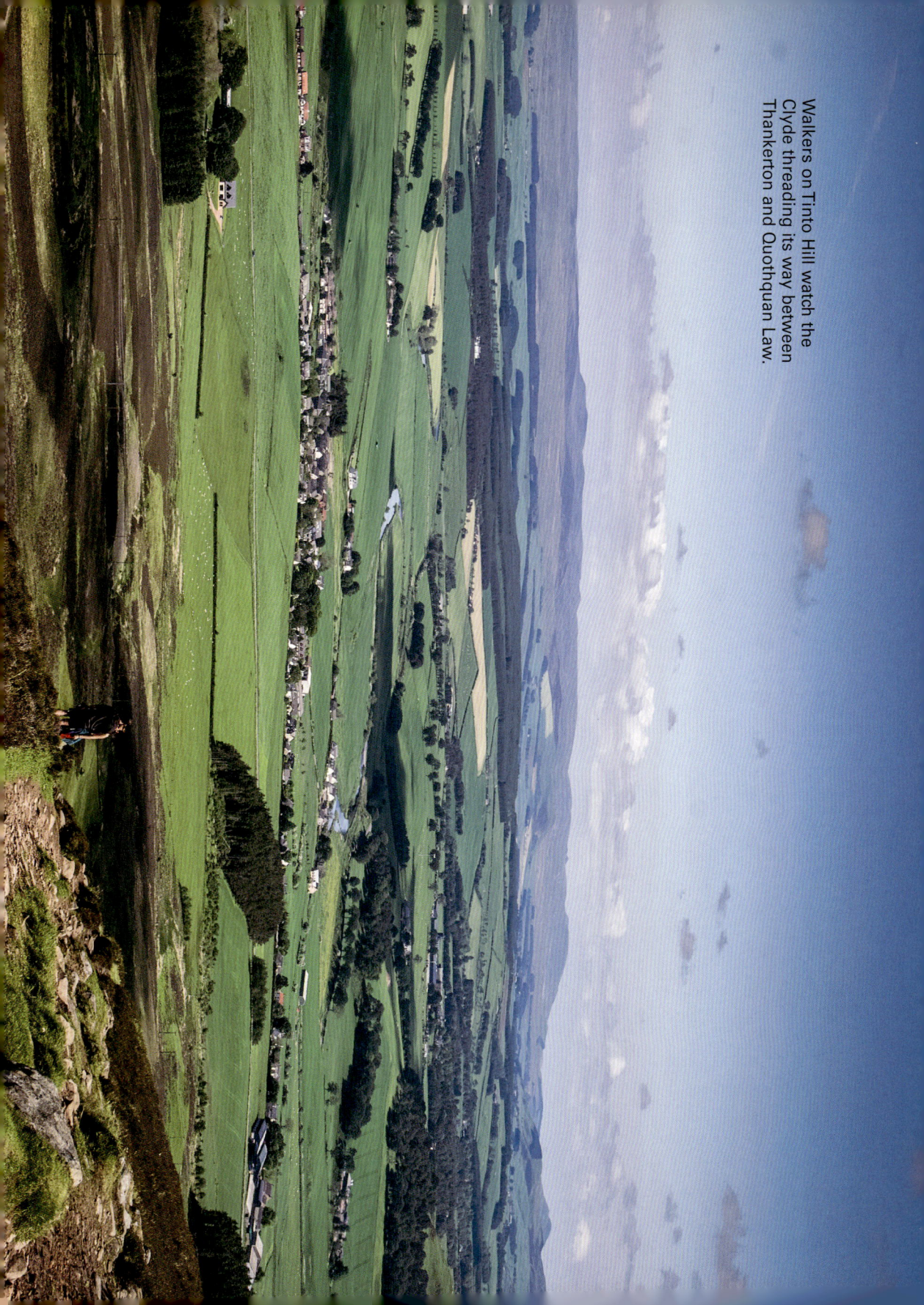
Walkers on Tinto Hill watch the Clyde threading its way between Thankerton and Quothquan Law.

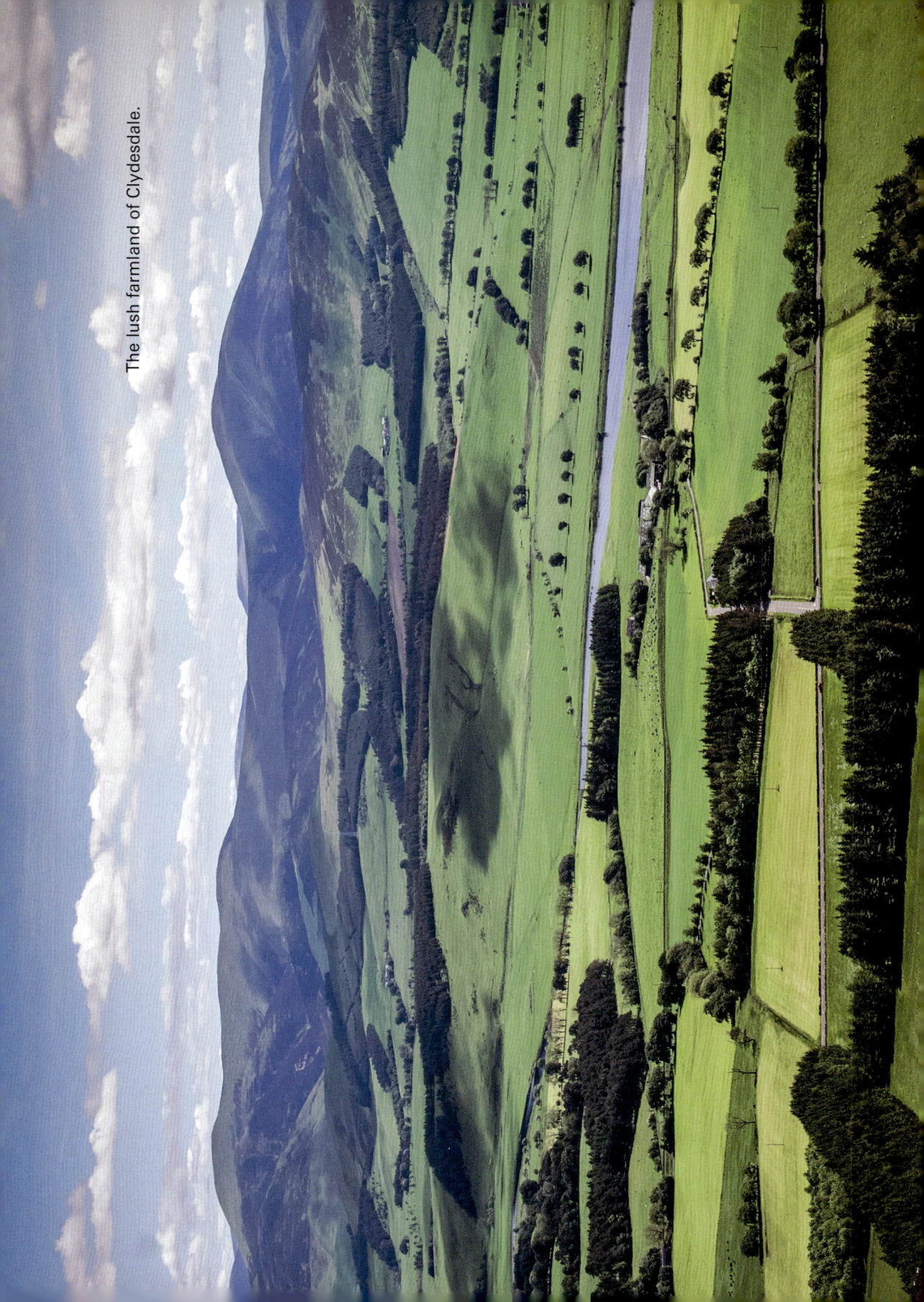
The lush farmland of Clydesdale.

BIGGAR

Although Biggar isn't on the Clyde itself, it's part of the life of the river. For centuries the farmers who worked the fertile Clydesdale fields brought their livestock here to market. If you're exploring the area it's a good place to pick up some lunch and rather interesting local history.

Gas lamps in the nineteenth century weren't lit with natural gas, but with gas made from coal. The gasworks in Biggar was one of the first small-town operations in Scotland, and among the last to close, finally stopping output in 1973. It lives on as a fascinating museum, with the boiler and much machinery still intact and operational. Biggar also boasts the country's only permanent puppet theatre, and if you travel through the town in November and December, you'll notice a pile of scrap wood in the main street. This grows over the darkening weeks to a truly gargantuan stack, as high as the facing houses, by Hogmanay. The whole lot goes up in a mighty bonfire before a delirious, drunken crowd – one of the biggest in the country. It's a wonder it doesn't melt the paint from the shop window frames nearby.

gives you a sustained view of the high fences and frowning buildings of Scotland's only maximum-security psychiatric hospital. It's not a stretch of the Clyde that people flock back to explore at their leisure, but the area does have its points of interest.

After veering westwards just before Biggar, the river passes the wonderfully named Wolfclyde (no wolves hereabouts nowadays – the only hunters are fishermen). Still visible here are the supports of a bridge that once carried a railway branch line from Symington through Biggar and Broughton and on to Peebles. It threads between the hamlet of Thankerton and Quothquan Law, through an avenue of rich farmland, and then noses its way out of the hills of the southern uplands on to a different sort of landscape. Here the riverbanks flatten into an alluvial floodplain, and the bedrock of the valley is carpeted with a deep-pile covering of material ground off the hills by glaciers before any human ever walked here.

The North and South Medwin rivers unite, then saunter westwards across the flats to join with the Clyde at the imaginatively titled 'The Meetings'. These tributaries, like much of the upper Clyde area, are rich in sand and gravel, deposited by glaciers. Many pits and mines have been sunk to retrieve this valuable mineral resource, several of which are still in operation.

CARSTAIRS AND CARNWATH

If you've ever taken a train up the West Coast from England to Edinburgh on a dreich day, you may have got an ominous aura from Carstairs. As the train branches off the line to Glasgow, it slows to walking pace round a tight curve. This

Just to the north of The Meetings is the town of Carnwath, home to the world's oldest foot race. Running might be all the rage now, but it's nothing new. King James IV gave the lands hereabout to Lord Somerville

'Smile, Daisy, we're going to be in a book!'

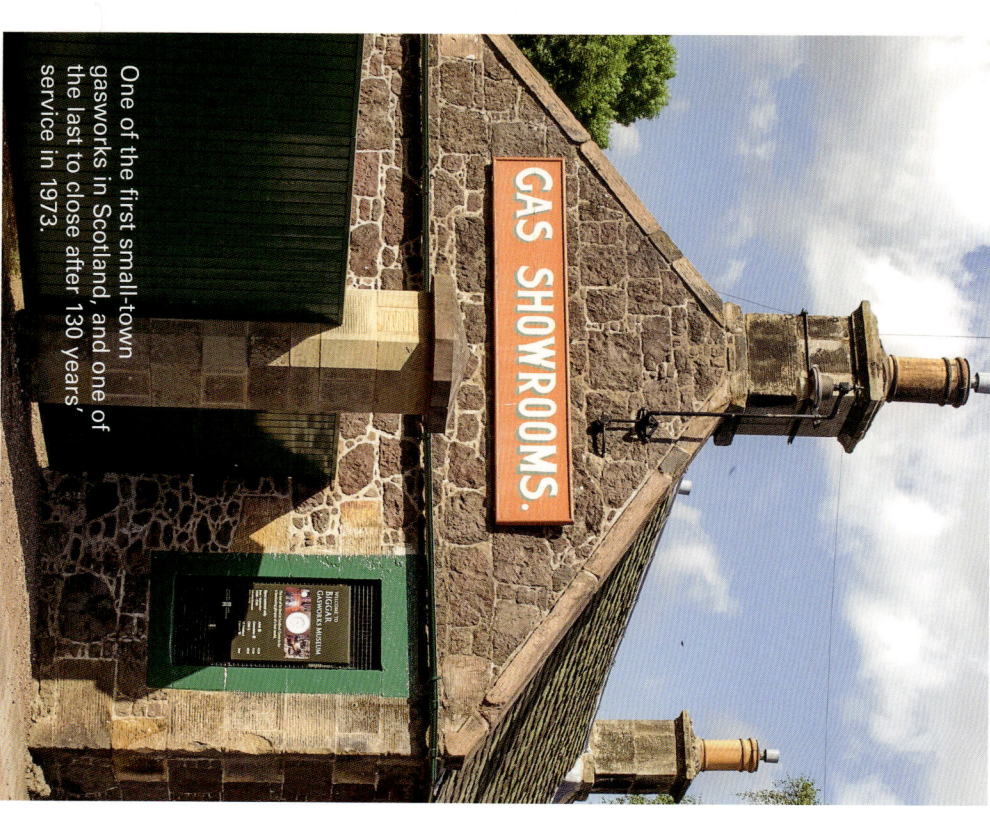

One of the first small-town gasworks in Scotland, and one of the last to close after 130 years' service in 1973.

in 1508 with one express condition: he must find Carnwath's fastest runner every summer, by offering the prize of 'one pair of hose containing one half an ell [21 inches] of English cloth at the feast of St John the Baptist, called Midsummer ... to the man running most quickly from the east end of the town of Carnwath to the cross called Cawlo cross', a distance of 3 miles. Today that prize equates to a hand-knitted pair of red socks, perhaps not the most glamorous of athletic trophies, but the local laird still offers it. The race has only been cancelled four times in 500 years, for two world wars and two outbreaks of foot-and-mouth disease.

On the same low slab of land is Lampits Farm, which was bought by the Ministry of Labour in the 1920s and turned into a labour camp. Men from the mines and other industries in the west of Scotland were trained here in farm and forestry work, ready for a new life in Canada or Australia.

This ceased in 1935, and Lampits returned to agriculture. Before it did, the inmates were tasked with building a new secure hospital. The Army used this in the Second World War, and in 1948 it became the 'State Institution for Mental Defectives'. This has evolved into today's more tactfully named State Hospital, where 700 staff care for 140 patients with the most demanding psychiatric needs.

The Clyde's next few miles are placid and very rural; the only crossing is made by the elegant stone spans of Hyndford Bridge, which dates back to 1773. Reaching a wooded curve

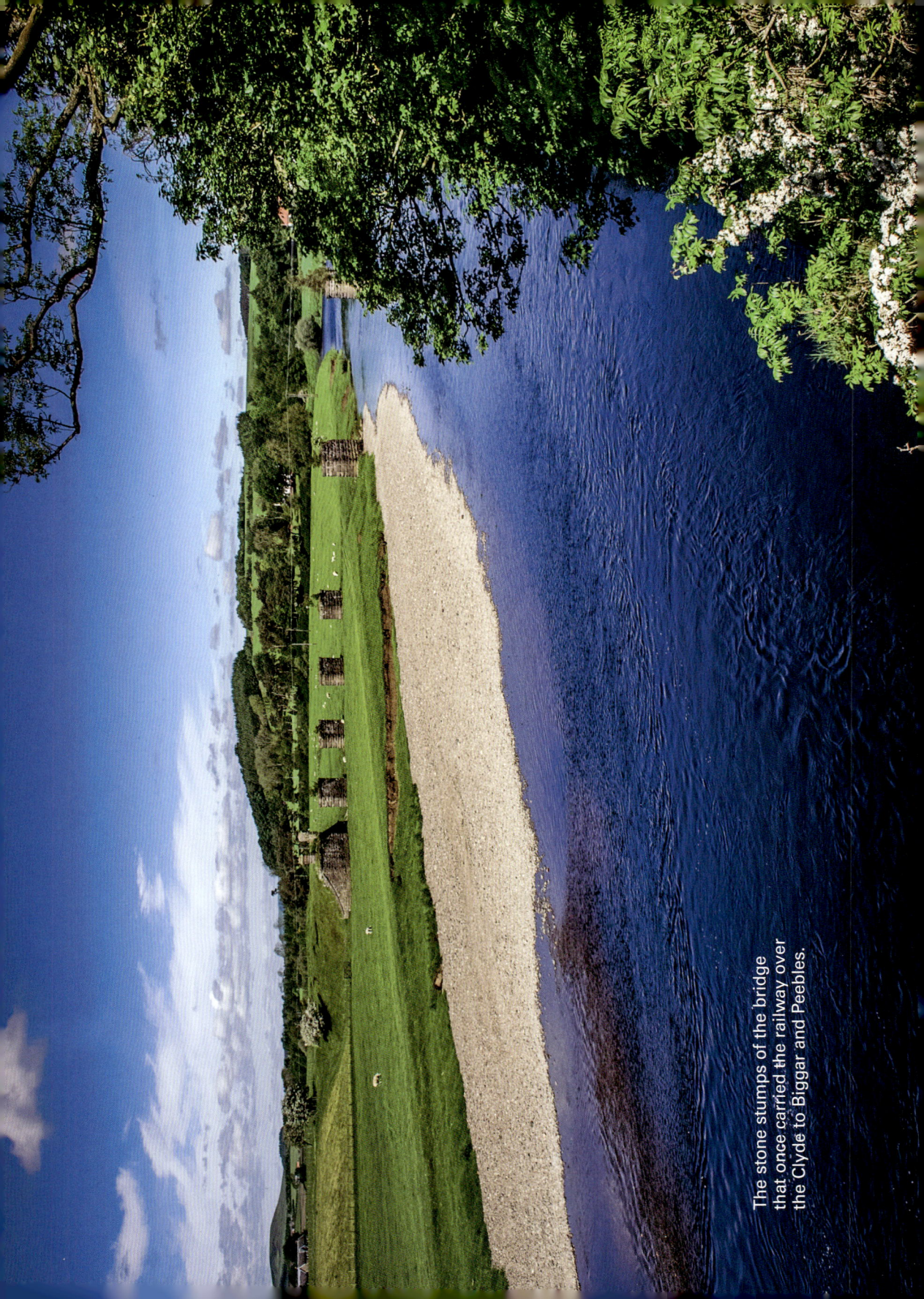

The stone stumps of the bridge that once carried the railway over the Clyde to Biggar and Peebles.

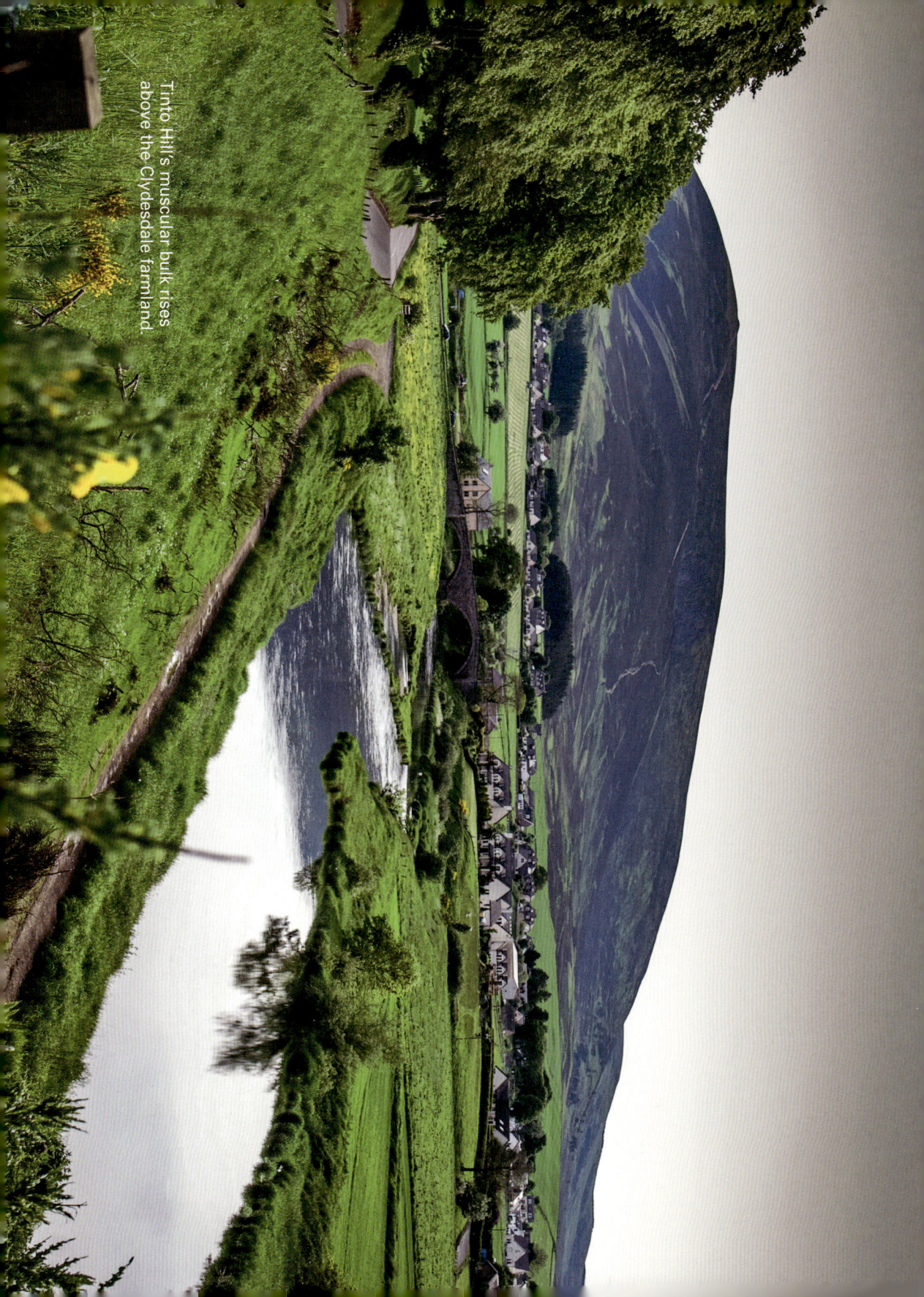

Tinto Hill's muscular bulk rises above the Clydesdale farmland.

by Linnhead Farm, the river seems to barely inch along, as if gathering its courage for the mighty leaps ahead – the Falls of Clyde.

FALLS OF CLYDE

At Bonnington Linn (a linn is a waterfall or a pool at the base of one) the Clyde changes its character on a Clark Kent/Superman scale. From dozily meandering through a wide alluvial valley, it transforms into a rampaging torrent, crashing through a rocky gorge. Over the next 1.8 km, the Clyde will drop 55m; upstream of Bonnington it takes the snoozy river 32 km to fall the same height.

The reason? It's that pesky ice age again. Debris carried by glaciers blocked the Clyde's original course when the ice melted. A lake then formed behind this natural dam. The Clyde was forced to cut itself a new escape route deep into the bedrock, creating the Falls of Clyde.

If you were canoeing downstream this would mean that the wide, low banks would rise and squeeze inward. The river turns a corner and suddenly drops away over its first plunge – the Bonnington weir. This is man-made, built in 1927 to house the intake pipes for a power station further downstream. This was the first hydroelectric plant in Scotland and it still runs today, generating 11 megawatts of power. The Bonnington bridge is the last one until Kirkfieldbank 5 km (3 miles) further downstream. It's the crossing point if you want to explore the west bank of the Clyde after parking at New Lanark.

The next waterfalls are all natural and much more spectacular. First is the Bonnington Linn, a curtain-like waterfall 11 m (36 ft) high, which takes the Clyde sharply round the corner to the north. This fall has a tree-covered island in the middle that was once reachable by a precipitous iron bridge. Today only the girders still span the tumultuous waters.

After Bonnington Linn the waters funnel into a slot gorge and then gallop down a 27-metre series of cascades. This drop is the most spectacular fall on the whole river, indeed one of the most beautiful in the whole country: Corra Linn.

Corra Linn thrills all the senses. Sudden mists scatter sunbeams, the moist air is rich with the soft smell of damp leaves and, as you get closer, the river revs into a throaty roar of excitement about its ride down the rocks. There are plenty of places to peek through the trees and see the water coiling and swirling before it suddenly drops into freefall. Come after a downpour (which is fairly easy to do, this being the west of Scotland), and even from the walkway high on the gorge-side, the power of the water will take your breath away. The otters who dive into this maelstrom for their breakfast are brave fellows.

It's no wonder that the falls have been drawing artists and writers for centuries. The great English landscape painter J. M. W. Turner captured the mists and swirling light of Corra Linn. Sir Walter Scott and

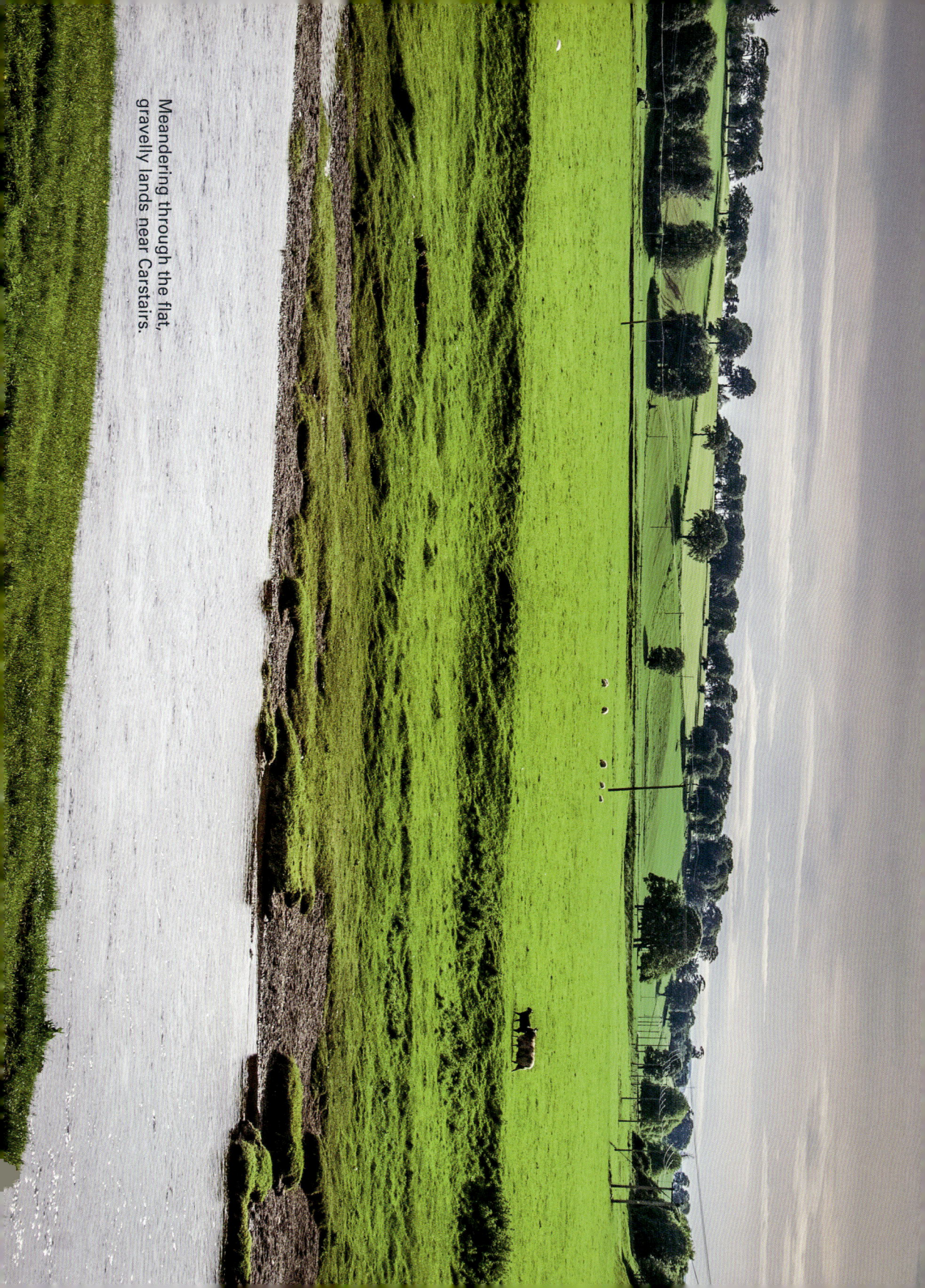

Meandering through the flat, gravelly lands near Carstairs.

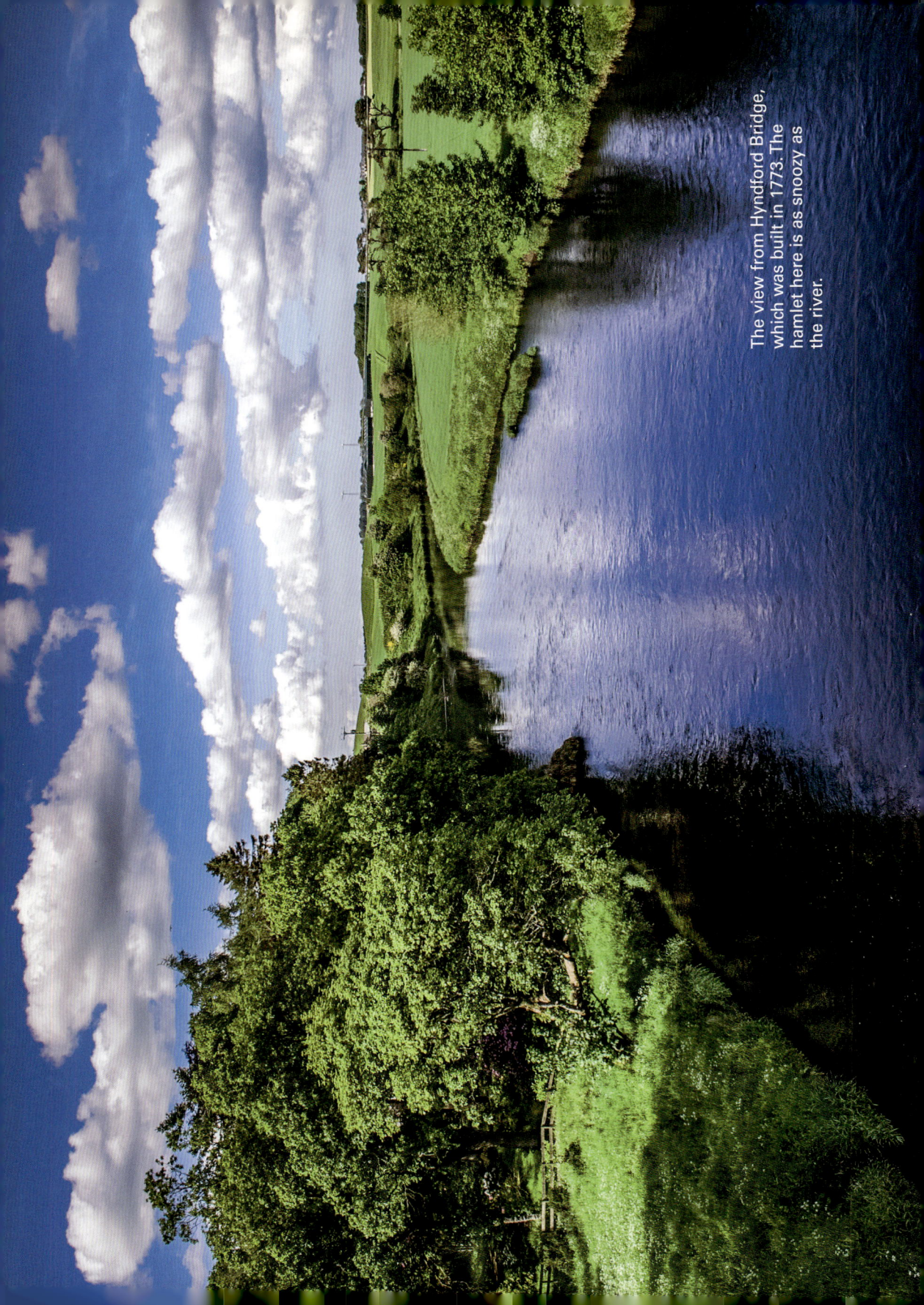

The view from Hyndford Bridge, which was built in 1773. The hamlet here is as snoozy as the river.

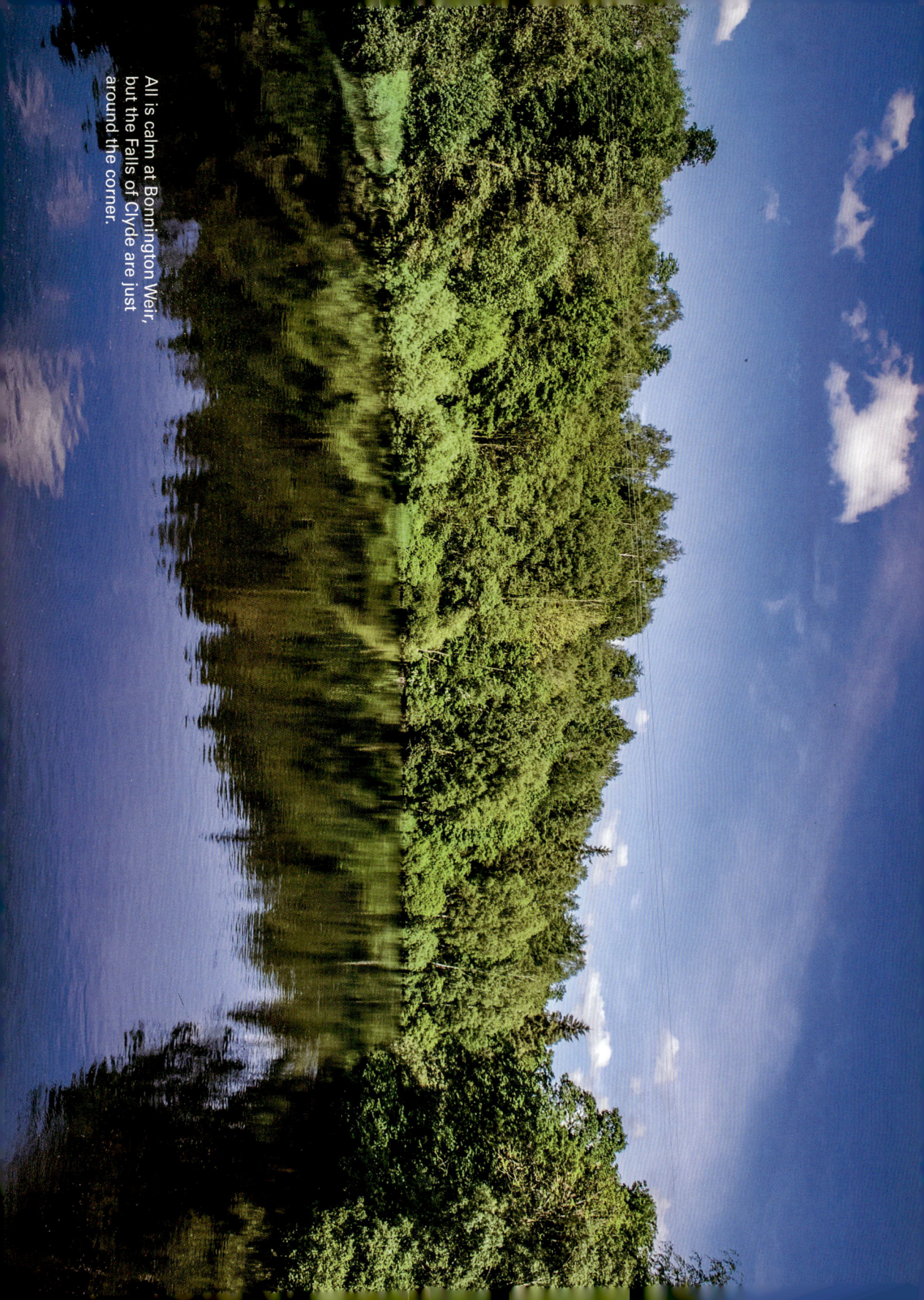
All is calm at Bonnington Weir, but the Falls of Clyde are just around the corner.

Moving through the gears – the Clyde rushes out from Bonnington Weir, but there are much bigger drops just ahead

Bonnington Linn takes the river 90 degrees round the corner.

The mightiest of the Falls of Clyde, Corra Linn, is really a series of cascades.

Samuel Taylor Coleridge were notably lost for words after the experience, while Coleridge's friend William Wordsworth praised Corra Linn in poetry as 'the Clyde's most majestic daughter'.

The river ravine is home to 100 species of bird, including kingfishers and the fastest creatures on earth – peregrine falcons – which can swoop at up to 200 mph. In the breeding season, which begins around April, you can view these birds through scopes and CCTV from the manned hide that perches on the edge of the gorge. Other interesting wildlife here includes roe deer, bats, the brook lamprey and pine martens.

Corra Linn was named from the Gaelic *currach* (a marshy place), rather than after a young girl. Near Corra Linn is a pavilion, built by a local landowner in 1708. There was a belief among the aristocracy that nature was cruel and ugly, and that fine ladies had best view it in a mirror or frame to avoid damaging their delicate sensibilities. Mirrors on the back wall seemed to suspend viewers below the falls.

The last of the Falls of Clyde, Dundaff Linn, drops just 3 m (10 ft), but in many ways it is the most remarkable of them all. It was here that a weir was built to draw off water to power the revolutionary mills of New Lanark.

WALK 2
TINTO HILL
DISTANCE: 8 KM
TIME: 2.5 HOURS

From the car park at Fallburn off the A73, follow the very obvious track south-west up the hill. For the return, a good path breaks east just a couple of hundred metres back down from the summit. This gives panoramic Clyde views from Scout Hill. Further down, the path fizzles out about 500 m from the road, requiring a bit of freestyling through a field of bullocks. The walk back along the A73 is scenic but close to fast traffic. It's probably better to head north-west at Wee Hill, skirting the contours to meet up with the original path. Or simply go up and down the same route.

The walk up Tinto Hill is short, but the views are terrific.

NEW LANARK

BIRTHPLACE OF CARING CAPITALISM

Next time a small person you know complains about having to do their homework, point out that children at New Lanark had to do two solid hours every evening – *after* working for thirteen hours in a cotton mill! Incredibly, this was a pretty good life compared with working class kids in the rest of the country.

Social experiment, profitable factory, industrial catalyst, UNESCO World Heritage Site, beauty spot – New Lanark is all this and more. In 1785, this was just a leafy spot by some crashing waterfalls on the river before three men came here and enacted a vision that would transform the glen into an industrial powerhouse. They harnessed the waters of the Clyde and used its power to radically reshape Britain's economic and social landscape.

David Dale was a grocer's son from Stewarton in Ayrshire, who became a highly successful linen merchant. In 1785, he entered a partnership with Richard Arkwright, an Englishman who had already made his name by industrialising cotton-spinning south of the border. They bought what was then a very rural gorge famed for its powerful waterfalls, and set about building cotton mills on a scale previously unheard of in Scotland.

The first step was to harness the power of the Clyde. A weir was built 600 m (1,970 ft) up the river to gather water. This flowed into a tunnel and then along a lade to the mills.

After a year, Arkwright left the partnership, leaving Dale in sole control. He kept building and, by the early 1790s, he had four fully functioning cotton mills. In 1793, there were 1,150 workers, 800 of whom were children (the orphanages of Glasgow and Edinburgh provided an endless source of youthful labour).

Other recruits were Highlanders evicted from their land by the clearances. For many, a life in a Lanarkshire mill seemed a better bet than an uncertain future in the New World. When Dale expanded the housing at New Lanark, he christened one street Caithness Row to make its inhabitants feel less homesick.

A twenty-seven-year-old Welshman called Robert Owen visited New Lanark in 1798, at the suggestion of Dale's

New Lanark's tenement rows are laid out neatly in the river valley.

The Clyde tumbles into New Lanark. Its power has already been harnessed by a weir just upstream.

The mill lade is almost as wide as a canal and runs right through the centre of the village.

The workers' houses have been perfectly restored and are lived in once again. All come with river views as standard.

Robert Owen's house was just a wee bit bigger than the workers' tenement flats.

daughter, Caroline. Owen had made his name as a mill manager in Manchester and he persuaded his partners to buy the place. He snapped up New Lanark on 1 January 1800 for £60,000, and bagged Caroline too.

Owen was initially regarded warily by the Scots workers – hardly surprising considering his first act as boss was to increase the working day from thirteen hours to fourteen. He enforced stricter discipline, sacking anyone who was found drunk three times. This was sensible really – you don't want half-cut workers fooling about with heavy machinery.

Productivity and profits shot up, and New Lanark was the biggest cotton mill in Scotland. More than 2,000 people lived or worked here. Owen then launched a program of bold ideas that were hugely beneficial to his workers. Historians disagree about whether these were motivated by a sense of social justice or the realisation that happy workers are more productive, but they were undeniably around 100 years ahead of their time.

He began to win the hearts of his employees. In 1806, he kept workers on full pay despite there being no cotton to spin because of a trade dispute with the USA. True, it would have been hard to recruit a new workforce when trade did pick up, but this was more than many mill owners did at the time.

In 1809, he constructed nursery buildings and moved the orphans from their dormitories in Mill 4 to this more welcoming home. Mill owners then usually paid workers in tokens that were only redeemable at their own mill stores, where the goods were shabby and overpriced. It was a racket. When Owen opened a village store in New Lanark in 1813, the stock was cheaper and good quality. It was a prototype cooperative movement – Owen bought in bulk and passed the savings on to the workers.

His financial partners baulked at these advances and Owen was forced to buy them out in 1813, taking control of New Lanark for £114,100. With the help of Quaker investors more sympathetic to his ideas, he began the second phase of his revolutionary developments at New Lanark.

In 1816, he built an Institution for the Formation of Character. This sounds Orwellian, but it was actually Owen's attempt at an all-round educational establishment. As well as a schoolroom on the ground floor, it had an upper room where the walls were hung with zoological specimens and maps, and there was a gallery for an orchestra. The space was used as a lecture hall, a ballroom and dancing and singing lessons were given there daily. The institution had its own central heating system.

The next year he opened the first infants' school in Britain. His instructions to the new teachers were simple: 'They were on no account ever to beat any one of the children or to threaten them in any word or action or to use abusive terms; but were always to speak to them with a pleasant voice and in a kind manner,' He really did seem to understand infants, stating that, 'The children were not to be annoyed with books; but were to be taught the uses and nature or qualities of the common things around them,

by familiar conversation when the children's curiosity was excited...'

Owen began to phase out child labour – practically a heretical notion among industrialists. The profits of the shop were now put into paying for the youngsters' schooling, which meant he could keep it all but free for the workers. He also established a sick fund for his workers.

Owen must have felt that his work here was done; in 1824 he set off for America. He wanted to repeat his advances in a new Utopian community called New Harmony in Indiana. New Lanark was taken over by two of Owen's Quaker colleagues, Charles and Henry Walker. For the next fifty years they continued running the mills and the village in the spirit Owen had established. Sadly, New Harmony wasn't as successful as New Lanark and after five years Owen returned much lighter in pocket.

In 1881, New Lanark was taken over by the Gourock Ropemaking Company. Its owner was of the 'if it isn't broken, don't fix it' school of thought, so he kept the social welfare schemes untouched. He started producing ropes, fishing nets and began weaving cotton on site, as well as spinning it. Fishing nets were tested by being stretched across a hole in the floor and having cannon balls of varying sizes dropped upon them from above. New Lanark was

Right: The whole village is a museum, with displays in several different buildings.

Exchange their poverty for wealth, their ignorance for knowledge, their anger for kindness, their divisions for union.

Robert Owen

Above: Not the catchiest of company slogans, but an impressive one.

Opposite right: The village nestles beneath steep glensides and a dense wood of mature trees.

The New Lanark complex was the biggest mill in Scotland in its heyday.

now producing canvas for the Army, deck chair covers and even the big top for Bertram Mills Circus. Workers got tickets when the circus came to Lanark. The mills were powered by water wheels until 1929, when water turbines took over. Further improvements were made, with mains electricity being installed and indoor 'stairheid cludgies' replacing the old communal outside toilets in 1933.

The Gourock Rope Company closed the mills with the loss of 350 jobs in 1968. It was then a close-run thing with New Lanark – it nearly ended up as a pile of very historical bricks. In 1970 it was taken over by a metal-working company and the village rapidly deteriorated into the country's most historic scrapyard. The site came within a whisker of being completely demolished.

Luckily a visionary conservation trust was formed in 1974, and it set about a program of restoration that would, over 30 years, enact a dramatic transformation. Craftsmen working on the restoration were forbidden from using power tools; wooden beams had to be trimmed to fit with an adze (known as an *eetch* in Scots).

Mill 1 is now a beautifully converted hotel. Robert Owen's Institute for the Formation of Character today provides education for tourists rather than orphans. The Engine House has a restored steam engine. Robert Owen's personal house is a museum and the Dyeworks is now the visitor centre. There are still two rows of houses yet to be restored – hopefully this will go ahead soon. The Clyde is still at the heart of the village – today a turbine in Mill 3 uses the river to provide electricity.

In 2001 all this hard work was rewarded when New Lanark was given World Heritage Status by UNESCO. No one can knock it down now.

You have to say it deserves this accolade. Visit today and you'll see a beautifully restored model village. The trust ensures that no television aerials or satellite dishes are allowed in the village; it's easy to step back in time and imagine the mills in their heyday, when the river turned the wheels all day long and 2,500 people worked and lived here together. New Lanark is proof of Owen's forward-thinking notion that industrialism and social responsibility could work together. His ideas about childcare, education, healthcare, cooperatives and the trades union movement seem more reasonable today.

It's not just a museum; 200 people actually live here, which gives the place a nice energy. You can walk around the village and soak up what it's all about without spending a bean. The Youth Hostel is a great idea. The visitor centre is subtly done and there's none of that 'exit through the gift shop' hard sell. The guys in the bird hide will spend ages telling you what's going on and let you use their binoculars. New Lanark really does make for a fun afternoon out. The history bit is going to pass younger kids by, but hey – waterwheels! Peregrine falcons! Otters! It draws 500,000 visitors a year and long may it continue.

54 RIVER CLYDE

Curiously, the last time we were there a bunch of Americans were taking photos of the red telephone box, which is about as historically authentic as the ice cream stall.

WALK 3
FALLS OF CLYDE
DISTANCE: 5 KM
TIME: 1.5 HOURS

Park in the main New Lanark car park and head down into the village. Turn left and pick up the 'badger' signs for the Falls of Clyde walk. As you pass the Visitor Centre, pop in and pick up a walks leaflet. The walk to the Falls continues into the woods and past the power station. There are some steps and it can be muddy, so boots are best. Once you've seen the cascades it's worth going on to the bridge at Bonnington Weir. This gives you access to the tracks on the far side of the river. Note: if you want to make a round trip of it, there is no bridge at New Lanark. The nearest crossing is 6 km (3.7 miles) downstream at Kirkfieldbank with another 2.5 km (1.5 miles) back up to New Lanark, so make sure you have plenty of sustenance.

Opposite right. Perhaps such a beautiful setting made it hard to be a truly ruthless employer.

This page: The walkway to the Falls is a nature-watcher's paradise.

Opposite left: A preserved mill wheel still turns today.

FROM COUNTRY TO CITY

KIRKFIELDBANK TO UDDINGSTON

From Kirkfieldbank to Garrion Bridge, the Clyde flows through an often-idyllic rural landscape of farms, woods and orchards, many of them on the estates of once-mighty country houses.

It's worth making a diversion as you head out of Lanark to see Cartland Bridge on the A73. Built in 1822 by Thomas Telford, it carries the road 39 m (128 ft) above the Mouse Water (a tributary of the Clyde), and is one of the highest bridges in Scotland. The gorge it crosses is so deep and steep that drivers rarely notice the bridge, despite its size.

Just along the Clyde is the 21 m (69 ft) drop of Stonebyres Linn, which proves a step too far for salmon and sea trout trying to migrate upriver. After passing Stonebyres Power Station, sister of the plant at Bonnington, the Clyde and its accompanying walkway pass Valley International Park, formerly the Carfin Estate. This is perhaps the most beautiful of the many country house estates in this part of the world and its miniature train has been particularly beloved by children for many years.

The Clyde swings round the village of Crossford, where it picks up the River Nethan. A little further up this tributary is Craignethan castle, a well-preserved sixteenth-century fortification where Mary Queen of Scots reputedly spent here last night of freedom. Mind you, she seems to have stayed in practically every old house of any size in Scotland at some point.

Map addicts can make a diversion near here to pay their respects at the birthplace of surveyor and cartographer Major General William Roy. In 1784 he measured a baseline between Hampton and the hamlet of Heathrow, west of London, that became the basis of all subsequent surveys of the United Kingdom.

The village of Rosebank was built to house the workers from the Mauldslie Castle estate. This part of the Clyde valley has been a fruit farming area since the Middle Ages. Dozens of varieties of apples and pears have been grown

Opposite right: Telford's Cartland Bridge drops away into the ravine of the Mouse Water.

The Tudor-style country hotel in Rosebank village is far from authentic, but helps create a very pretty main street.

Below: Mauldslie itself may be long gone, but its lodge house is a castle in miniature.

Opposite left: A serene stained glass window inside Dalserf kirk.

Opposite right: When the ford was in use at Dalserf, the main street was mostly taverns. Today, it's a pretty row of cottages.

here, and plums are still popular. Most of the orchards seem to have been transformed into garden centres and there are several long banks of ruined greenhouses. The Castle itself was demolished in 1935, but the West Lodge still stands. This was designed by David Bryce, a master of the Scottish Baronial style of architecture, who also created the remarkable Fettes College, the Bank of Scotland HQ in Edinburgh.

The postcard-perfect village of Dalserf has an exquisite little kirk, built in 1655. It's hard to believe, but this was once a bustling ferryport, coal-miners' town, and home to religious rebellion. Its ford was bypassed by a bridge, the local mines fell into disuse, the Covenanters were consigned to history and its landlord refused to allow any more houses to be built. The village was cast into a slumber like a lowland Brigadoon and it has no plans to wake up any time soon.

Garrion Bridge actually has two bridges, one built in 1817 and a fellow span added in 2002 to ease the notorious traffic logjam caused by the old single-lane structure. The fruit firm Fyffes operated a banana ripery here for many years; it is now an antique centre.

MOTHERWELL

The tower blocks of Motherwell looming on the horizon are the first sign that the Clyde is about to change its country garb for the streetwear of the city. In the early nineteenth century Motherwell was a tiny farming hamlet of just 600 souls. A hundred years later it was a booming industrial town of 37,000 people and by 1930 it was the steel capital of Scotland.

In 1959, many of the mills were consolidated into a colossal new steel works, Ravenscraig. This was the largest hot strip steel mill in Western Europe, producing 3 million tonnes a year. It closed in 1992 and is now a massive brownfield site awaiting development into a new town. One account we read states that it is 'twice the size of Monaco'. Quite an interesting choice of comparison to make, there. There is one plate mill still in Motherwell, which rolls steel from Middlesbrough into assorted plates ready for industrial uses.

Tucked in just to the south of Motherwell is the Dalzell Estate. Once a royal hunting forest, this has many fine trees even today including ancient yews, cedars and an oak said to have been planted in the eleventh century by King David I. The Arboretum has one of the finest collections of indigenous and exotic trees in Scotland. Many of the rare trees were planted in the eighteenth century by Archibald Hamilton, the 4th Laird and a keen horticulturist. There is a neighbouring RSPB bird reserve at Baron's Haugh.

The Hamilton family were a mighty power in this area, and the Clyde now flows into what was once the 'Low Parks' of their greatest treasure, Hamilton Palace. The green riverbank here is the perfect place to sit awhile and read the ultimate tale of a fallen empire.

The kirk was built in 1655, but a hogback stone found in the kirkyard dates to c. 1100.

This page: The 1817 Garrion Bridge as seen from the 2002 one.

Opposite right: When the ford was in use at Dalserf, the main street was mostly taverns. Today, it's a pretty row of cottages.

GRANDER DESIGNS

Hamilton Palace was pretty big to start with; but when Alexander, 10th Duke of Hamilton, came into his title in 1819, he took the idea of upsizing one's home to an entirely new level.

Luckily for the Duke, he had won top prize in a once-in-a-civilization lottery: his ancestral lands around Hamilton lay on top of one of the biggest coalfields in Britain. With the Industrial Revolution moving through the gears right on his doorstep, the Duke was soon swimming in money, and what better way to splash out than on a spot of home improvement.

Working to plans originally drawn up by architect William Adam, he added a colossal north front 81 m (265 ft) long and 18 m (60 ft) high. By 1852 he had transformed what had been a thirteenth-century tower house into the finest stately home in Scotland, indeed, one of Europe's most magnificent.

The Duke didn't neglect the interior, furnishing its myriad rooms with the world's finest art and furniture from Versailles. The long room was hung with portraits by Mytens, Janssens, VanDyck, Kneller, three large Titians and the most famous picture of the entire collection: Daniel in the Lions' Den by Rubens. This room was also where the family exercised if it was damp out.

Known as 'El Magnifico', Hamilton was a famous dandy of his day. His obituary noted that he had 'a great predisposition to over-estimate the importance of ancient birth ... he well deserved to be considered the proudest man in England.' He was interested in Egyptology – so much so that he secretly arranged to be mummified after his death and have his body placed in a Ptolemaic sarcophagus that he had acquired in Paris and promised to the British Museum. The story goes that no one had the bottle to tell him that this sarcophagus was actually far too small for him, and the Duke only found out on his death bed. His last words were, 'Double me up.'

Subsequent Dukes found the Palace expensive to maintain. The coal seams could not last forever. The building was used as a naval hospital in the First World War and neglected. When Alfred, the 13th Duke, moved out to a smaller property, the Palace's days were numbered. Ironically, the *coup de grâce* was delivered by a miner's hand. The 12th Duke was a spendthrift who extended diggings into his own parklands in the search for easy profits. Despite the Duke's mine at Bothwellhaugh being 2 km north away on the other side of the Clyde, its vast excavations caused the Palace to subside. The building was condemned by the council and completely flattened in 1927.

If you're ever in Boston, you can see what the dining room from Hamilton Palace looked like; it has been reassembled in the city's Museum of Fine Arts. All that remains in Scotland of the 10th Duke's pride and grandeur is his Roman-style mausoleum. This lies just north of the site of Hamilton Palace

Hamilton Mausoleum is still surrounded by green space, but where the Palace lay to the south now stand a leisure centre and supermarket.

Opposite: The mausoleum's sleepy lion sculptures are rather wonderful.

This page: Officially the world's grandest dog kennels.

and is notable for its fine panelled masonry and a lofty 37 m (123 ft) high dome. The mausoleum also has the longest echo of any building in the world; it takes fifteen seconds for the 'clang' of a slammed door to die out.

But after this also began to subside due to the underminings, the 10th Duke and his ancestors were disinterred and re-buried in Hamilton's Bent Cemetery. Or, in the Duke's case, the Bent Double Cemetery.

Surrounded by gardens and parkland, Hamilton Palace lay in the middle of a grand tree-lined avenue that ran for 5 km (3 miles) north–south. At the far southern end of this was Chatelherault, a hunting lodge and dog kennels built in 1732. Today this is the visitor centre of a 500-acre country park that is very popular with walkers and families. At one time the courtyard was used as a menagerie, with bears, wolves, leopards and baboons all prowling around the parterre. You can still see the distant mausoleum from its lawn, but Hamilton's housing estates now lie where the Dukes once took their hounds to hunt. There are 16 km (10 miles) of walks to explore along the wooded gorges of the River Avon, which joins the Clyde just before Strathclyde Country Park.

STRATHCLYDE COUNTRY PARK

The land on the west bank of the Clyde was once the 'Low Parks' of Hamilton Palace. This area is now covered with Hamilton Park racecourse, the M74 and Strathclyde Country Park.

There has been racing at Hamilton since 1782, and the course hosts the race for one of the world's oldest sporting trophies: the Lanark Silver Bell. This prize was gifted to the royal burgh of Lanark by William the Lion in 1160. It was originally raced for at Lanark racecourse, but that closed in 1977.

Strathclyde Loch was created in the early 1970s. The Clyde was diverted westwards and you can see the river's original course between the east loch shore and the island. Creating the loch meant flooding the old mining village of Bothwellhaugh, and the ruins of the village lie underwater to this day.

Today Strathclyde Loch is popular with anglers and watersports enthusiasts, although they aren't always popular with each other. On the east side of the loch lie the remains of Bothwellhaugh Roman Fort and a nearby Roman bath-house.

The nearby motorway means this isn't the quietest of parks, but it has some beautiful nooks and it provides a welcome green lung between the flanking urban masses of Hamilton and Motherwell. Strathclyde Country Park was the birthplace of the T in the Park music festival, which was held here from 1994–96.

BLANTYRE

The Clyde flows serenely under the rumbling M74 and a couple of roads. It was at a crossing here that the

The old odds/results board at the defunct Lanark racecourse.

Hamilton Park racecourse was the first in Britain to hold evening and morning meetings.

The Clyde's very own beach. The river used to run to the right of this island, but this is all now Strathclyde Loch.

Battle of Bothwell Bridge was fought in 1679. After the Restoration of King Charles II, the Presbyterians in Scotland found themselves under the religious cosh. Many of the more vocal Presbyterians rallied their fellows in illegal outdoor meetings, known as conventicles.

Charles's son James, Duke of Monmouth, was sent north to sort them out. He raised a militia of 5,000 and routed the badly organised Covenanters here on 22 June. The survivors were imprisoned in Edinburgh and then transported, ending the rebellion.

Now the river starts a pleasant run of curves between steeper, wooded banks as it runs down to Blantyre. Mills were founded here in 1785 by David Dale, of New Lanark fame. The workers lived nearby in a row of cottages and it was in one of these, in 1813, that David Livingstone was born. Livingstone's parents and their seven children all lived in one tenement room and his dirt-poor early life perhaps explains the sympathy he later felt for African slaves. David began work aged ten, but the lad had an incredible desire for self-improvement and an almost supernatural ability to concentrate. The noise and dust in the mills must have been almost overwhelming, but he would prop his book up on the spinning jenny and read as he worked. He studied in the evenings after his shifts, taught himself Latin and eventually made it to Glasgow University where he studied medicine.

He joined the London Missionary Society after graduating, was ordained in 1840 and set off to spread the gospel in

It's easy to miss this memorial to the Covenanters by Bothwell Bridge.

The more picturesque of the two road bridges at Bothwell.

This page: Livingstone really was attacked by a lion, but he was rather embarrassed by the incident and probably wouldn't have wanted it immortalised in bronze.

Opposite: Shuttle Row, the tenement the Livingstones shared with twenty-three other families, is now a museum.

Bothwell castle's precipitous position was no match for Edward I's cunning.

central Africa. He was the first white man ever seen by many villagers. His medical skills, particularly in obstetrics, earned him the thanks and trust of many villages. But it was as an explorer and anti-slave trade activist that he made his name. In 1855 he was exploring the Zambezi when he discovered Victoria Falls. This enormous cataract had, of course, already been discovered by the people who lived beside it, but they had neglected to tell anyone in Western Europe about it.

Livingstone's adventures and abolitionist writings made him something of a secular-saint-cum-literary-superstar. When he later disappeared for several years, the journalist Henry Stanley was dispatched to find him, at any expense. In what must be the world's most elaborate and successful case of celebrity stalking, Stanley found him after two years and a 700-mile nightmare trek through a pathless rainforest. He then uttered the famous phrase, 'Dr Livingstone, I presume?' Incidentally, Livingstone wasn't lost but had known exactly where he was all the time, and was perfectly content to remain there, thank you very much.

Livingstone worked in Africa until his death at the age of sixty in 1873. His devoted African servants then embalmed his body and carried it hundreds of miles to the coast so it could be shipped back to Britain and buried in Westminster Abbey.

At Blantyre you can see items from his Africa explorations and how his family lived and worked back in Scotland. There's also a very dramatic sculpture of Livingstone being attacked by a lion.

From here it's just a 2.5 km woodland stroll along the Clyde Walkway to Bothwell Castle. It really does feel like a different world down here; anglers pluck salmon from the quiet waters, small boys drop from 'tarzans' into pools and bird watchers scan the canopy for new visitors. Strange to think that in just a few miles we'll be in mighty Glasgow....

BOTHWELL CASTLE

Suddenly standing to attention, red and proud above the trees, is Bothwell Castle. This is Scotland's largest and finest thirteenth-century castle and it stands in a terrific position high on a bank above a crook in the Clyde.

Built by the ancestors of Clan Murray, it guards a strategic crossing point of the river that has seen a fair few skirmishes over the centuries. Looming over travellers is an impressive circular tower that was originally 25 m (82 ft) high and 19 m (62 ft) in diameter, with walls 4.5 m (15 ft) thick.

Edward I of England captured Bothwell on two separate occasions during the Wars of Scottish Independence. In 1301 he used an enormous siege engine or 'berefrey' (belfry) to take the stronghold. This was built in Glasgow, disassembled and transported by thirty wagons in a two-day journey here. Wooden wheels allowed it to be rolled right up to the walls and it was so tall that a drawbridge was simply dropped down on top of the tower, with soldiers then rushing over.

Bothwell was in English hands before the Battle of Bannockburn, and was used as a refuge for many fleeing English nobles, until the castle constable handed the castle and refugees over to the Scots. This act earned him the barony of Cadzow and his descendants became the powerful Hamilton family.

The next 2 km of the walkway are the last truly leafy part of the Clyde riverbanks, so breathe deeply and enjoy the peace – things are about to get busier. Up to your right, behind the trees, is Uddingston.

UDDINGSTON

Every week, millions of school breaktimes are a little bit brighter thanks to Uddingston. Well, to the Tunnocks factory that is sited in the town, anyway; for this is home to the famous caramel wafer and tea cake. Thomas Tunnock opened shop on Main Street in 1890, and for sixty years the business ticked over as a simple baker's. But in 1952 it introduced a bold new product – the caramel wafer. This was a time when rationing severely reduced the options for sweet-toothed youngsters. The wafer was an instant hit. Tunnocks quickly followed it up with three more belters: Snowballs, Caramel Logs and Teacakes (what a run of form!). It became the biscuit-making behemoth it is today. The company is now run by the founder's grandson, Boyd Tunnock, who invented the tea cake in 1956. In the interests of research your fearless authors embarked on a rigorous sampling programme of Tunnocks products and we can confirm that they are as tasty as they ever were.

Just before the railway bridge, the Clyde Walkway leaves the river, and it's bit trickier to explore the next 3 km. However, this isn't the most interesting part of the river – you're only missing a golf driving range and a sewage works. The walkway rejoins the water at the old railway bridge by Carmyle and as the industrial buildings proliferate, you feel you've finally entered the east end of the mighty city of Glasgow.

WALK 4
BOTHWELL CASTLE
DISTANCE: 5 KM
TIME: 2 HOURS

From the David Livingstone Centre car park, walk out of the gates and head left down the lane to the green metal bridge over the river. Cross this and turn left into the woods, then bear left down to the riverside path. Follow this until it rises up to Bothwell Castle. Return the same way.

Note: The Clyde Walkway runs for very nearly the whole length of this section of river. You can download leaflets to all sections of this walk at www.southlanarkshire.gov.uk.

The castle's remains are rectangular, but it once covered an area almost double this size.

This page: The steep, craggy banks around Bothwell have protected the riversides from development.

Opposite: Tunnocks was just an ordinary baker's shop until the 1950s.

Left: The factory is one of the area's biggest employers, with 550 tea cake makers.

Opposite right: 200 years ago, this corner of the river was packed with mills and their belching chimneys.

GLASGOW EAST & CENTRAL
INNOVATION AND INDUSTRY

Historians say that 'Glasgow' comes from the Welsh *glas*, and *cu* or *gu*, meaning 'beloved green place' (although everyone knows it's really an acronym for Granny Likes A Small Glass Of Wine), and if anywhere epitomises that affectionate term it's Glasgow Green.

To get there Clyde runs through the city's post-industrial east end. It's not the most scenic part of the river, but this area has an astounding history of engineering innovation. In particular, the city's locomotive manufacturers developed here, helping the city become known as 'the locomotive builder to the world'. The North British Locomotive Company alone built over 26,000 steam locomotives.

From the Clyde Walkway it's easy to spot the stands of Celtic Park, the largest football stadium in Scotland with a capacity of 60,355. Another major feature here is the Forge retail centre built on site of Parkhead Forge, part of Beardmore's steel works that closed in 1983.

GLASGOW GREEN

Glasgow Green may not have the grand landscaping or scenic features of many other city parks, but it can probably boast more history per blade of grass than any other.

It is the city's oldest park; the common lands were given to the people by Bishop Turnbull in 1450. This wasn't amazingly generous; the area was then a boggy floodplain cut by many streams, including the Calmachie Burn, which was as wide as the Clyde in some places. Since then this space has been close to the hearts of citizens and the life of the city.

Although it was much used by the people, it was far from the parkland we see today. This was a working open space where people washed themselves and their clothes, bleached linen, dried fishing nets and grazed their sheep. It was still being used for grazing at the end of the nineteenth century. The city's first 'steamie', or public washhouse, was built on Glasgow Green by the banks of the Camlachie Burn in 1732.

Opposite right: One of the thousands of locomotives produced in Glasgow's railway works.

5

Calm amid the palms – stopping for a cuppa in the Winter Gardens.

It was here, in 1765, that a university lab assistant was mooching about one Sunday with his head in the clouds when those grey Glasgow puffs of water vapour suggested an amazing use for themselves. The lab assistant was Greenock-born James Watt and he had recently been given a Newcomen steam engine to tinker with in the hopes of improving it. His cloud-inspired notion was the separate condenser. This saved the energy lost in heating and cooling the cylinder. His improvements made it five times as efficient. He also adapted it to make rotary motion. It could now move things, as well as pump water. Watt's idea was one of the biggest breakthroughs in the Industrial Revolution, and it would radically alter the very place where he had come up with it.

The account he gives in his journal notes that after passing the steamie (or washhouse), it came into his mind that '...steam was an elastic body, it would rush into a vacuum and, if a communication were made between the cylinder and an exhausted vessel, it would rush into it and might be condensed without cooling the cylinder... I had not walked further than the golf house when the whole thing was arranged in my mind.'

In 1790 a wealthy local merchant, James Coulter, bequeathed £200 to found the Glasgow Humane Society, the goal of which was 'to recover those who are apparently dead, from having been sometime under water, from being exposed to intense cold, or to other causes capable of suspending life without destroying it'. The society still aims to preserve human life in and around the waterways of Glasgow today, and houses a full time officer on Glasgow Green.

The current officer, George Parsonage MBE, has rescued 1,500 people and recovered 500 bodies. He writes up each day's work in a logbook and these fascinating records stretch back to the eighteenth century. The reasons for deaths were once recorded. Those who fell from bridges were often, unsurprisingly, 'the worse of liquor'. Suicides were in a 'desponding state of mind', 'labouring under mental derangement' or suffering from 'brain fever'. It's almost too sad to read of people drowned 'trying to sail a toy boat', 'while attempting to drown a cat near to Polmadie ferry', and while 'slightly unhinged by bad news from abroad'. George also looks after the 300 lifebelts placed along the riverbank, and patiently retrieves and replaces the two dozen of them that are lobbed into the river almost every day by people who should know better.

TEMPLETON CARPET FACTORY

John Templeton was a Paisley lad who built one of Britain's most prestigious carpet businesses. Templeton carpets brightened the floors of stately homes, palaces and luxury liners, including (later) the Titanic. When he bought a site to the east of the Green, the well-heeled residents of nearby Monteith Row didn't want to have to look out of their windows at anything as tawdry as a

The Officer of the Human Society still lives and works on Glasgow Green.

They don't build 'em like they used to, especially when it comes to carpet factories.

carpet factory, and a word in the right ear saw the council reject design after design proposed by Templeton. He eventually tasked Arts & Crafts architect William Leiper with creating a building that might meet their approval. Leiper rubbed his hands, went to work and in 1892 produced a fabulously ornate façade inspired by the Doge's Palace in Venice. Its confection of glazed bricks, enamel tiles, and terracotta flourishes echo the rich Oriental patterns of the furnishings once produced inside, not something that you can imagine DFS doing today. The factory employed 3,000 people in its heyday, but closed in 1979. The building became a business centre six years later.

DOULTON FOUNTAIN

The Doulton Fountain is famed for being the world's largest terracotta fountain. The history books don't say what the second largest terracotta fountain is, so this isn't perhaps the most hotly contested of world records, but the Doulton is a fine structure nonetheless. It stands 14 m (46 ft) high and its lower basin is 21 m (70 ft) wide.

Queen Victoria stands proudly atop the world's biggest birdbath.

Queen Victoria herself balances deftly on the very top, supported by four water-carriers and figures representing the imperial colonies in India, Canada, South Africa, and Australia. Beside them are sculptures of soldiers from the Black Watch, Grenadier Guards, Royal Navy and Irish Fusiliers. On the lowest basin are inscriptions and figures celebrating Glasgow.

It was created by Sir Henry Doulton, of the famed Royal Doulton pottery dynasty, for the International Exhibition of Science, Art and Industry held in Kelvingrove Park in 1888. This showcase for Glasgow's industrial, cultural and scientific achievements was the greatest Victorian exhibition held outside London. It made a profit of £43,000, which was spent on building the Kelvingrove Art Gallery and Museum.

The fountain was one of the most popular attractions, and when the exhibition finished, Sir Henry gave it to the city as a celebration of Queen Victoria's recent Golden Jubilee and, cannily, a hardy advertisement of his firm's capabilities. In 1890 it was moved from Kelvingrove to Glasgow Green. Its magnificence was never topped because creating such an object was extremely difficult and time-consuming, and terracotta soon fell from fountain fashion.

By 2002 it was looking as shabby as you might expect a ceramic fountain to look after a century in Glasgow's East End. It was given £5 million worth of tender loving care and moved to its current position outside the People's Palace.

One of the largest glasshouses in Europe, the Winter Gardens adjoin the People's Palace.

Nelson's Monument towers over the Commonwealth Games stalls in July 2014.

PEOPLE'S PALACE

In 1898, the east end was a teeming warren of slums and factories. The People's Palace was opened as a cultural haven in these industrial badlands. It had reading and recreation rooms on the ground floor, a museum on the first floor and an art gallery above that – just what the working class needed to educate and amuse themselves. Today the Palace is a museum dedicated to the lives of those ordinary citizens. The restful winter garden, with its palms and café, was supposedly designed to resemble the prow of Victory, Nelson's flagship.

OTHER MONUMENTS

The McLennan Arch was designed by Robert and James Adam, but not as an arch. It was built as the centre-piece of the grand first floor of the Assembly Rooms in Ingram Street. When this building was demolished the arch was saved and moved to the Green.

The first monument to England's famous Admiral Horatio Nelson stands on Glasgow Green. The 43.5-metre obelisk was erected just one year after the great man died at his moment of triumph in the Battle of Trafalgar. This was two years before the building of Nelson's Pillar in Dublin (since blown up by the IRA) and 37 years before London managed to complete its celebratory Column in Trafalgar Square.

JUSTICIARY COURTHOUSE

Greek revival architecture first came to Glasgow in the fine form of the Justiciary Courthouse. With elegant columns and a distinctive portico, it was built from 1807–14 as an all-purpose judiciary building combining courtroom, offices, gaol, and place of execution. From 1814–65, sixty-seven men and four women were publicly executed on the Green outside the judiciary 'facing the monument', as this fate became known. Since being remodelled in 1910–13, it has served solely as courthouses.

SPORT AND RECREATION

Four rowers taking a break on the riverbank watched some lads kicking a football around on Fleshers Haugh (once owned by the butchers' incorporation) in early 1872. Impressed, they formed their own team – Glasgow Argyle. They played their first match, against Callander F.C., on Flesher's Haugh in the east of the Green in May. The result was a drab 0-0 draw, but they won their next game 11-0. They soon changed their name to Rangers Football Club and moved to their own ground.

The Glasgow Golf Club was formed here in 1787, but as James Watt mentions the 'golf house' in his account of his famous walk, it was probably played long before that.

The year 2014 saw hockey join the ranks of sports being played on the Green, when the new Scottish Hockey

Built in 1751, St Andrew's-by-the-Green is one of the city's oldest church buildings.

Scotland's hockey team salute the home crowd at the Commonwealth Games.

This page: Strolling along one of the Green's avenues. In the background is Merchant's Steeple, built in 1665.

Opposite: The St Andrews footbridge looks strong, but it bounces up and down quite a bit if you jump on it.

centre, with two synthetic pitches and a 500-seat stand was built for the Commonwealth Games. Glasgow Green also hosted the start and finish of the marathon, road cycling and time trial events.

The Green makes for a very special music venue; Michael Jackson, The Stone Roses and Metallica have all taken to the stage here. Several events return here every year, including the World Pipe Band Championships, Great Scottish Run and Glasgow Show.

A PLACE FOR POLITICS

The Green has a proud history of public speaking and political campaigning. The reading of Gladstone's Reform Bill drew hundreds of thousands of people here and it was a favoured meeting place of the Suffragettes. Protesters recently gathered on the Green against the Iraq war.

The Green's survival has often been threatened by development. Plans were drawn up for a railway viaduct across it and a coal mine under it in the nineteenth century. In the twentieth century it was a motorway that was being considered. The people of Glasgow have long regarded the Green as their place, and they were so vocal in their objections that all of the plans were dropped. Long may they keep their voices.

GLASGOW'S CLYDE BRIDGES

Now that we're into the city centre, this is a good point to take a look at Glasgow's bridges. The St Andrews iron footbridge was built in 1853-55 so that engineering and textile workers could move more easily between the areas of Hutchesontown, Bridgeton and Calton. A few hundred metres downstream, a bridge and weir marks the upper tidal limit of the Clyde.

Ahead is the first of the big city centre bridges, Albert Bridge, the fifth to be built in this position. Its partner, the Victoria Bridge, lies on the far side of the City Union railway bridge, which once carried trains over the Clyde into St Enoch station. This station and its hotel were demolished in 1977 and the rubble used to fill in Queen's Dock, on which the Scottish Exhibition and Conference Centre (SECC) was built.

South of the river is the Gorbals, the name of which was once a synonym for 'slum'. But it has enjoyed a fair amount of regeneration in the last twenty years. Famous people from the Gorbals include Allan Pinkerton, founder of the famous American detective agency, tea baron Sir Thomas Lipton, Poet Laureate Carol Ann Duffy, cyclist Robert Millar and Lorraine Kelly.

The towers of the South Portland Street suspension bridge were built in 1853, making them the oldest part of any of the Clyde's city bridges.

The Glasgow (or Jamaica Street) Bridge is an 1899 replica of an earlier Thomas Telford bridge, although it is

It'll rain later – Albert Bridge has put on his purple waterproof.

The paddle steamer *Waverley* splashes past the *Glenlee* at the Riverside Museum.

The Clyde Arc is called the 'Squinty Bridge' because it crosses the river at a distinct angle.

This page Bell's Bridge and the 'Armadillo', which from this angle looks more like an enormous croissant.

Opposite: The St Andrews footbridge looks strong, but it bounces up and down quite a bit if you jump on it.

6 m (20 ft) wider. This marks the start of the Broomielaw, Glasgow's first quay, which runs to Finnieston Quay.

Broomielaw became famous as the place where thousands of Glaswegians gathered to go 'doon the watter' for a day trip or seaside holiday. Elegant paddle steamers would spirit them down the Clyde to exotic desinations such as Largs, Dunoon and Rothesay on the Isle of Bute. Many rich business people used the steamer services to commute, spending weekends in their country villas and coming in to work in Glasgow during the week. The *Waverley*, the world's last seagoing paddle steamer, now sails from the Science Centre to Rothesay and Largs.

Only the granite piers of the 1st Caledonian Railway Bridge remain; the deck was removed in 1967. Its sister bridge, the 2nd Caledonian Railway Bridge was the widest railway river crossing in the country when it opened in 1905. Together the bridges carried thirteen tracks in Central station.

The George V Bridge opened in 1928 after ten years of delay caused by the First World War. It closed off the Clyde upstream to ships, and steamers had to sail from the south bank of the river.

The Tradeston Bridge, or to give it its official title, the Squiggly Bridge, was opened in 2009 to boost the Tradeston area.

The Kingston Bridge is the largest urban bridge in the United Kingdom and one of the busiest road bridges in Europe.

Built in 1970 to carry a maximum of 120,000 vehicles a day, its ten lanes now regularly carry 150,000. Starting in 1990, the badly deteriorating structure was given a decade-long overhaul. Engineers lifted the 52,000-tonne deck of the bridge with 128 hydraulic jacks, while traffic still used it, to repair the supports beneath. This was the biggest ever bridge lift according to the Guinness Book of Records, a remarkable feat, but one that is hard to be impressed by when you're stuck amid five lanes of roadwork-snarled traffic. The bridge also gives you a view of both Celtic Park and Ibrox.

Opened in 2006, the Clyde Arc – sorry, Squinty Bridge – links the south bank media village with the SECC and the north bank.

Bell's Bridge was built to link the Garden Festival site with the SECC. Its spans can rotate on the south pier to allow vessels to pass.

The steel Millennium Bridge of 2002 gives access to the Glasgow Science Centre development. Its two centre spans can lift up to allow passage.

Below the river are several tunnels. The Clyde Tunnel was planned in 1948 to allow shipping to continue to use Glasgow's docks, but by the time it eventually opened in 1963, shipping was using ports downstream and new bridges, such as the Kingston, were built downstream of the city centre. Kids often try to hold their breath for the duration of the journey through the Clyde Tunnel – if you're doing 30 mph this will take 57 seconds, making this a satisfying challenge.

The Finnieston crane and the northern rotunda of the old Clyde tunnels.

Also under the river bed near Glasgow Bridge in the east, and Govan in the west, are the tunnels of the Glasgow Subway. This opened in 1896, making it the third-oldest underground metro system in the world after the London Underground and Budapest Metro. Unlike other systems, it has never been seriously expanded. Its circular lines are just 6.5 miles long and its 4-foot track gauge makes for dinky trains. It does merit one superlative: it is easily the world's least stable underground railway.

At Finnieston you can see two iconic brick rotundas flanking the Clyde. Completed in 1896, these gave access to the Harbour Tunnels that carried vehicles and pedestrians 24 m (79 ft) below the river. In 1986 the vehicular tunnels were filled in; the pedestrian tunnel still exists but is closed to the public.

From the riverside here you can see the Gothic tower of Glasgow University on the hill above Kelvingrove Park. The city's university is the fourth oldest in the English-speaking world, and its medieval buildings were established on the east side of the High Street. But in the nineteenth century the surrounding area deteriorated into slumland. Rather than sort the slums out, the Victorians simply flattened this near-perfect medieval college and built a new campus on a then-greenfield site 5 km (3 miles) to the west of the city at Gilmorehill. Where the university had been they built a train shed.

The Hutcheson brothers were merchants who left money for this hospital (built in 1802) and a school.

The old Sheriff Court is a beautiful neo-classical building that is now home to a restaurant and the Scottish Youth Theatre.

Cafés and bars abound in the streets at the back of the City Chambers.

GLASGOW CITY CENTRE

Step away from the river to explore the heart of Glasgow and you can still see the elegant city built by the wealth that flowed up the Clyde. Glasgow is an architectural gem. With its elegant grid layout, outstanding buildings, graceful squares and stylish shops it's no wonder it's one of the UK's most popular film locations. But within living memory this came very, very close to being completely wiped out.

Radical doesn't begin to describe the Bruce Report of 1945. At the end of the Second World War it was obvious that Glasgow needed significant regeneration, but this plan proposed virtually bulldozing the whole city.

The planners' intentions were good – the inner city was a smoky sprawl of crammed slums. They wanted to create a 'healthy and beautiful city' that would be much less dense and built along the clean lines of 1950s architecture. It's also important to remember that, to them, the Victorian and Edwardian buildings that we value so much were as ugly, outdated and disposable as the 1960s and 1970s concrete structures that we hate.

The report advocated several actions to achieve its goals: demolish the inner city slums and move people to new satellite suburbs; build a motorway ring road round the inner city; rationalise the rail and bus stations, and flatten many Victorian and Georgian buildings to create a coherently planned city.

The 1626 Tolbooth steeple stands alone and out-of-time amid the modern buildings of Glasgow Cross. Public hangings used to be held here.

The tenements of Anderston and Townhead, which really were slums by then, were totally flattened. In their place were built high-rise houses, office blocks and the M8. It did work; the inner city population dropped from 1.1 million to 600,000. But it generated such a storm of protest that the plan for the rest of the ring road was shelved and many fine buildings saved. Bruce proposed demolishing all four of Glasgow's Victorian railway stations and replacing them with two new ones. This wasn't put into action, but St Enoch and Buchanan Street were closed under the Beeching Axe in the 1960s.

Had the plan been fully implemented, the city would have been unrecognisable. The Kelvingrove Art Gallery and Museum, Glasgow School of Art (designed by Charles Rennie Mackintosh),City Chambers, Royal Infirmary and Central station would all have been demolished.

Today's planning regulations might seem conservative and complicated, but they're there for a reason.

WALK 5
GLASGOW CENTRAL RIVERSIDE
DISTANCE: 5 KM
TIME: 2 HOURS (+ DAWDLING TIME)

Start at the bottom of Saltmarket, just before Albert Bridge. Turn left onto Glasgow Green and follow the riverside path, passing the boathouse on your right. Wander off to explore Glasgow Green for a bit. Return to cross the blue suspension bridge and turn right along the south bank of the river towards the city centre. Continue all the way along until you reach the Squiggly (Tradeston) Bridge. Cross the bridge, turn right and after the casino, turn left up Oswald Street. Turn right under Central station and go along Argyle Street. St Enoch Centre is to your right, Buchanan Street and then Merchant City to your left. Continue along the Trongate, and turn right down Saltmarket to reach your starting point.

GLASGOW WEST
SHIPBUILDING CENTRE OF THE BIGGEST EMPIRE ON EARTH

Shipbuilding on the Clyde is the stuff of legend, particularly now that it has dwindled to just a handful of specialist yards. This fame occurred in a narrow window of time; before the eighteenth century, shipbuilding was unheard of on the Clyde.

Before then, the majority of Scotland's overseas trade was done with the Low Countries and Scandinavia, and the river was simply on the wrong side of the country to serve those routes. The busy harbours were at Leith and in Fife, and consequently it was in these places that ships were built.

But, with the establishment of British colonies in North America and the West Indies, a port on the west of Scotland became much more useful. In England, Liverpool enjoyed a similarly prime position.

The first bale of tobacco was unloaded onto a Glasgow wharf in 1674. The political union of 1707 gave Scottish merchants access to English colonies and within a few years a tobacco boom had hit the city.

As well as being on the right side of the country, the trade winds helped ships make the voyage from Virginia to Glasgow up to twenty days quicker than to London. Time saved meant more trips and more profit. Soon almost half of all the tobacco coming into Europe was landing at Glasgow. Going the other way, the ships were filled with locally made pottery, textiles and other essentials that colonists couldn't readily get hold of.

In 1735, a total of sixty-seven ships sailed down the Clyde, heading for locations including Virginia, Jamaica, Antigua, St Kitts and Boston. They came back with around 10 per cent of America's tobacco crop, but within fifteen years, Glasgow handled more of the trade than all the other ports in Britain combined. (Is it any wonder that Glasgow has long had the highest rate of smoking in Scotland?)

A new species of merchant evolved – the tobacco laird. Men such as John Glassford and William Cunninghame used large, fast American ships (there was still little shipbuilding on the Clyde) and took risks to generate spectacular rewards. For fifty years the tobacco lairds enjoyed an aristocratic existence. They gave their names to streets in today's Merchant City area, lent their

patronage to the arts and endowed churches, such as St Andrew's in the Square. You can get a fair idea of their wealth when you consider that what is now the Glasgow Gallery of Modern Art was built in 1778 as a townhouse for William Cunninghame.

Their success was partly built on giving tobacco growers cheap credit and then stiffing them on the price of their crop at harvest time. The growers were constantly in debt and eventually got rather angry. The American War of Independence put an end to the glory days of tobacco trading. Many of the lairds then cannily switched to cotton trading in the West Indies.

The tobacco lairds also left a legacy that would help the next stage of Glasgow's growth. The first quay in Glasgow had been built by merchant Walter Gibson in 1688 at the Broomielaw, stretching for 240 m along the north bank of the Clyde. But the Clyde was not the river we see today, it was heavily silted with a clearance as low as 1.2 m (4 ft) at high tide at Broomielaw. Its lower reaches were dotted with dangerous sandbars and it was so shallow between Bowling and Dumbarton that you could wade across at low tide. Large cargoes had to be landed at deeper ports downstream – Dumbarton, Greenock and Port Glasgow – and carried into the city by pack horses or on smaller boats. The lairds spurred the councillors into starting a program to deepen the Clyde.

If you've ever built sand canals on the beach for the incoming tide to rush through, you'll know how fast-

This page: William Cunninghame's pad in the city – a neo-classical palace. This is now the Modern Art Gallery. The Duke of Wellington is sporting his cone as usual.

Opposite: The merchant halls and houses are now home to fine restaurants and some of Britain's best shopping.

The piles of a breakwater on the lower Clyde, as would have been used when the river was deepened.

moving water behaves in a narrowed channel – gouging down the way.

From 1771, engineer John Golborne designed a series of piers and breakwaters that would encourage the river to deepen itself. By 1775 the river had scoured its bottom down to 2m deep, and by 1781 this had increased to 3.7 m (12 ft). The celebrated dock-builder John Rennie Snr stepped up the project from 1799, increasing the number of groynes from 50 to over 500. The river's work was aided with extensive dredging.

By the 1790s, ocean-going vessels of 100 tons and more could sail up to Glasgow. The deepening continued into the early nineteenth century and by the late 1820s, more than 700,000 tons of shipping tied up at Glasgow's quays every year.

In 1830 the river's clearance was 4.6 m and by 1871, ships could count on 6.7 m (22 ft) at high water all the way from Greenock to the Broomielaw quays — a distance of 35 km (22 mi). There were now 5,124 m (3 miles) of quays in Glasgow, up from 349 m (1,145 ft) in 1801, and 30.6 ha of harbour, up from 1.6 ha. In 1894 the minimum available depth below Glasgow at high water was 8.4 m (27.5 ft).

Glasgow now had all the benefits of a deep-sea harbour in an urban heartland. Its docks were less than a mile from the factories, warehouses and homes of the workers. As well as boosting cargo operations, the deepening of the Clyde drew shipyards to the upper reaches of the river.

A few more pieces then clicked into place: the Battle of Trafalgar in 1805 ensured continued British control of the high seas; steam technology had been revolutionised by Greenock's own James Watt, and rich coal mines and huge iron foundries were developed in Lanarkshire.

Suddenly Glasgow was ideally placed to capitalise on the new technology of iron-built, steam-powered ships. From 1860–70, more than 800,000 tons of iron ships were built on Clydeside. Vast shipyards were laid out at Clydebank, Finnieston, Govan, Kelvinhaugh and Scotstoun. Shipbuilding and engineering replaced the textile industries and spawned whole new towns of shipyard workers. Govan was a village of 2,500 handloom weavers in 1800. The first shipyard opened in 1840 and the town had a population of 9,000 by 1864. By 1907 there were 95,000 residents. Clydebank didn't even exist in 1861, but by 1901 it had a population of 30,000.

Industry was everywhere in Glasgow, with mills, mines, foundries and shipyards sprouting into being. The population of the city as a whole grew from 12,000 people in 1700 to 566,000 in 1871. Today it is around 593,000.

One interesting by-product of this huge population increase was an explosion in entertainment. Dozens of music halls, saloons, theatres and concert halls sprang up and did a roaring trade. The city became known as the Second City of the Empire for entertainment as well as industry. You can still see the Britannia Panopticon Music Hall, which is the oldest in Britain today, and was

Performers amuse the crowds in Merchant City.

where a sixteen-year-old Stan Laurel made his showbiz debut. The City Halls on Candleriggs hosted such stars as Charles Dickens, Oscar Wilde and Paganini.

nearly obliterated by the Luftwaffe in just two nights, from 13/14 March 1941. Only seven properties in the town were undamaged and the shipyards and factories were badly hit.

THE GOLDEN YEARS OF SHIPBUILDING

In 1876, more iron ships were built on the Clyde than in all the other shipyards on earth put together. At its peak before the First World War, the Clyde shipbuilding industry employed 70,000 workers in nineteen yards. The world's largest crane, with a lift capacity of 250 tons, was built at Fairfield's in 1911. This Govan yard then had twelve ships under construction. Around 750,000 tons of shipping were launched here, around one-fifth of the total world tonnage. This was an amazing achievement for a wee river 170 km (106 mi) long in a nation of less than 5 million people.

DECLINE OF SHIPBUILDING

The First World War brought plenty of Admiralty orders, but there was a gradual decline between the wars as US shipbuilding boomed. The problems were masked by high profile orders for headline-grabbing liners, with the *Queen Mary* and *Queen Elizabeth* being launched from John Brown's yard.

The Second World War kept the Clyde yards busy and drew the attention of the enemy. Clydebank was

The end of the war saw the end of large warship orders, and even a boom in merchant shipbuilding couldn't stop the decline setting in. The 1950s saw the Clyde yards being undercut by new shipbuilding superpowers like Japan. The industry reached a crisis in the late 1960s and the government created the Upper Clyde Shipbuilders (UCS) in 1968. This was an amalgamation of 8,500 workers in five yards – Fairfield's and Stephens on the south bank, Connel's and Yarrow's on the north bank, and John Brown's at Clydebank. It wasn't to last. Despite a famous 'work in' led by Jimmy Reid, by 1972 there were just two yards remaining: Yarrow at Scotstoun and Fairfield's at Govan.

CLYDE SHIPBUILDING TODAY

There are still three shipbuilding yards on the Clyde. The yards at Scotstoun and Govan are owned by BAE Systems and focus on complex warships. They are building the two Queen Elizabeth class of aircraft carriers for the Royal Navy. These are the largest warships ever built in the United Kingdom, with a displacement of 65,000 tonnes, length of 280 m (920 ft) and berths for

The Scotstoun shipyard pictured in between jobs.

The cocoon of a giant robotic moth, programmed to emerge and destroy Glasgow. Oh wait, I think that's actually the IMAX cinema.

up to 1,600 crew. The first, HMS *Queen Elizabeth*, was christened on 4 July 2014.

Further down the Clyde at Port Glasgow is the remaining builder of merchant vessels, Ferguson Shipbuilders. This family firm focuses on ferries. They have built many of the much-loved Caledonian MacBrayne, vessels, which shuttle around the islands of the Clyde and Hebrides.

GLASGOW'S DOCKS

As trade and industrial production boomed, Glasgow went through several phases of dock-building. The city's first enclosed dock was the Kingston Dock, on the south bank of the river, which opened in 1867. The dock was closed in 1966, the basin was subsequently in-filled and flats built on the site.

HMS *Dragon*, built on the Clyde, heads up the firth towards Loch Long.

A section of the aircraft carrier HMS *Prince of Wales* leaves its Clyde shipyard on a barge, heading for Rosyth where it will be pieced together.

The Queens Dock on the north bank of the river opened in 1877 with 61 acres (25 ha) of harbour. It closed in 1969 and was filled in. The SECC was built on the site in 1983. The massive Finnieston Crane, 53 m (174 ft) tall with a 46 m (152 ft) cantilever jib, was built in 1931 to lift locomotives onto cargo ships. Uniquely, it had its own electric lift.

Princes Dock, on the south bank, was Glasgow's third major dock complex and opened in 1897. It closed in the 1970s and was infilled. Redevelopment began in 1988 when the Glasgow Garden Festival was held on the 100-acre (0.40 km²) site. After lying derelict for some years it is now home to the Glasgow Science Centre, media village, an IMAX cinema and the Glasgow Tower. Built in 2001,

This page: The architect's right hand had a spasm but they built it anyway.

Opposite left: The Science Tower, choosing not to rotate today, but still looking very impressive.

Opposite right: The *Glenlee*, once a cargo vessel and training ship, now a beautiful museum piece.

this is 127 m (417 ft), making it the tallest tower in Scotland. It also goes down in the record books for being the world's tallest tower able to spin around 360°, but if truth be told it doesn't do that very much, having been dogged by technical problems for most of its existence. Looks braw, though.

The fourth port complex to open was George V Dock in 1931. This was a large, wide basin, able to take the larger cargo ships then being built. It is still open and busy today.

Many dockland redevelopments have fizzled out, but Glasgow's has picked up style and energy over the years. The Armadillo, or Clyde Auditorium, is a concert venue added to the SECC complex. In 2013 it was joined by the stunning SSE Hydro Arena in 2013.

With its unmistakeable crinkly roof, the Riverside Museum on Pointhouse Quay makes an iconic new home for the Glasgow Museum of Transport collection. It sits on the site of the former A. & J. Inglis shipbuilders, a busy yard that built 500 ships in just over 100 years. The museum is now home to the *Glenlee*, a steel-hulled three-masted barque, built in 1896 as a cargo ship, but which spent most of its life as a training ship in the Spanish Navy. In 2013 the Riverside was named European Museum of the Year, and deservedly so.

GOVAN

Today Govan is famed as a shipbuilding centre, but its history is much more ancient than that. Govan Old Parish Church has a heart-shaped churchyard, where excavations have revealed there was a church and burial ground here as early as AD 600–800. Some of the most important early Christian carvings in Scotland lie here.

Govan was still a thatched hamlet in the early nineteenth century, but shipbuilding changed that forever. Its biggest yard was Fairfield's, which was also the biggest shipyard in the world with a 5,000-strong workforce. Today the yard is one of the Clyde's three survivors, mostly building vessels for the Royal Navy.

Step away from the river and, somewhat incongruously, you'll also find Europe's largest Country and Western club. Glasgow's Grand Ole Opry has had them a-whoopin' and a-hollerin' in a converted cinema since 1974.

RENFREW

The shore at Renfrew was once home to the Braehead Power Station, which was demolished in the early 1990s. About 800 years before that, it was the site of a castle, built by the Lord of the Isles to stop rampaging Scandinavians from making Scotland a part of their international empire. Today it is an extensive shopping and leisure development, which can lay claim to having the UK's largest branch of IKEA, an irony if ever there was one.

But with most people heading inside for the various attractions, you can enjoy a pleasant riverside stroll along

the quayside. This is also the best place to get a view of the Scotstoun shipyard.

Dozens of ferries once tootled about the Clyde, but now there are only two. The Renfrew-Yoker service carried cars until 1984, but is now just for foot passengers. If you ask for the 'Renfrew Ferry', just make sure you mean the river crossing – one of the old ferry boats is now a nightclub in the city centre that goes by the same name. There is also a ferry at Govan.

Just inland from here is Glasgow Airport, the UK's eighth-busiest airport. This moved to its current location in 1966 – the old Renfrew airport was where the very flat section of the M8 is today. For years it was only allowed to handle European traffic, with Prestwick taking all the transatlantic flights.

WALK 6
GLASGOW DOCKS
DISTANCE: 3KM (EACH WALK)
TIME: 1.5 HOURS (EACH WALK)

From the Riverside Museum you can follow the signposted walk to Kelvingrove Park. This takes in the River Kelvin as well as the Clyde, and Kelvingrove Art Gallery and Museum. You can also head east along the river to the SECC, then cross over Bell's Bridge to explore the Science Centre, and return via the Millennium Bridge.

The Scotstoun shipyard as seen from the leafy riverbank by Braehead.

The old Renfrew to Yoker ferry pulled itself across the river using an underwater chain. Today's dinky vessel is powered by the passengers hanging their feet off the back and splashing.

Minehunter HMS *Bangor* visits the Science Centre. Across is the pump house tower of Queen's Dock and at the top the Riverside Museum.

'DOON THE WATTER'

CLYDEBANK TO THE OUTER FIRTH

Clydebank was the end of the world as far as the Romans were concerned. The town is built by the end of the Antonine Wall, which was the furthest northern frontier of their Empire. There is also the site of one of the forts that the Romans built at regular intervals along the wall. In 2008, the Antonine Wall was designated as a World Heritage Site, as part of a multinational Heritage Site encompassing the borders of the Roman Empire.

CLYDEBANK'S LANDMARKS

You can't miss the Titan crane at Clydebank – it's 46 m (150 ft) tall and was the largest cantilever crane in the world when built in 1907. It was specially designed to lift very heavy machinery, such as boilers and engines, into ships during fitting at John Brown & Company, perhaps the most famous of all the Clyde shipbuilders. These included the *Queen Mary*, *Queen Elizabeth* and *Queen Elizabeth 2*. The yard also built the RMS *Lusitania*, *Hood* and was the scene of the famous 'work in' led by Jimmy Reid in the 1970s.

The crane has a terrific view of Clydeside from the top of the Titan Crane. A lift zooms you up to the engine house and an exhibition (the operators had to climb the stairs). The Clydebank Museum at the Town Hall has some good displays of the history of the area.

Clydebank was also notable for the massive Singer sewing machine factory that once stood in the town. At its peak in the 1960s this boasted 16,000 employees and was the largest sewing machine factory in the world. It had a clock tower 61 m (200 ft) high and 5 km (3 mi) of railway track running around its buildings.

CREATIVE CLYDE

It's no surprise that a river with the Clyde's unrivalled history has inspired generations of artists. J. M. W. Turner painted the natural wonder of the Falls of Clyde. Atkinson Grimshaw turned the sooty, misty docks into beautiful images in their own way. Muirhead Bone drew ships under construction and became a celebrated war artist.

Scotland takes pride in the Clyde.

Clydebank's Titan crane dominates the evening skyline.

Atkinson Grimshaw's *Shipping on the Clyde*, 1881, makes the misty Clyde dockside look beautiful rather than dreary.

ERSKINE BRIDGE

For centuries people had crossed the Clyde at Erskine by simply waiting till low tide and then wading across, so shallow was the river. But when it was deepened to allow ships to sail further up, a ferry became essential. The oldest ferry crossing of the Clyde was from Erskine to Old Kilpatrick, was established in 1777. A boatman punted people across until 1832, when a chain ferry was built. In the 1850s, a steam-powered ferry called *Urania* entered service. The ferry was replaced by the Erskine Bridge in 1971, although the slipways can still be seen.

THE FORTH AND CLYDE CANAL

You only have to look at a map to see that the low-lying land of Scotland's narrow waist between the Forth and Clyde rivers was perfect for a canal. After twenty-two years of construction, the Forth and Clyde Canal was duly opened in 1790. This saved vessels heading for Edinburgh and Britain's northeast seaboard from braving the notoriously dangerous waters of the far north of Scotland. Ships joined the canal at Bowling and would exit 56 km (35 miles) later into the River Carron near Grangemouth. The canal had its own harbour in Glasgow at Port Dundas, near the workers, warehouses and factories.

It was closed in 1963 and suffered decades of neglect. Happily, the canal was largely restored as part of the

Many famous names started out in the shipyards themselves. Billy Connolly started out as a welder in John Brown's shipyard before turning to comedy, and Sir Alex Ferguson was born in Govan.

WILDLIFE

Like many rivers in the British Isles, the Clyde is currently enjoying a rebirth following a long period of industrial pollution. Trout, salmon, gudgeon, dace, chub, bream, perch and eels all abound in the water thanks to hugely improved water quality.

The outer firth has long been frequented by Grey and Common seals, Harbour Porpoises and occasionally dolphins. Pilot and minke whales occasionally pop by and orcas have been spotted at the firth's outer limits. Ferry passengers often see basking sharks idling alongside the ship.

INCHINNAN

Just west of Renfrew on the south bank is India of Inchinnan, a 1930 Art Deco office building that was once the HQ of a tyre company. In the airship era this was also the site of an enormous Airship Shed, built by Sir William Arrol & Co. At 220 m (720 ft) long, 70 m (230 ft) wide and 37 m (122 ft) high, it could berth two Class 23 airships side by side.

Wildlife in the Clyde. Still, it shows that the water's clean.

Winter comes to the mountains of Arran, in the outer firth.

The decrepit outer entrance to the canal at Bowling, with the Erskine Bridge in the background.

The inner canal basin is packed with leisure craft.

The blue waters of the Firth of Clyde, as seen from Dumbarton Castle.

millennium celebrations and is now very popular with walkers, cyclists, boat-travellers and ducks. There is a bike hire shop under the railway arches near Bowling basin; it's perfectly placed for train travellers wanting to jump off and explore the towpath.

DUMBARTON

Before the river was deepened in the eighteenth century, Dumbarton was the highest natural navigable point of the Clyde. It also happens to have a ready-made defensive position in the form of a mighty great lump of volcanic rock.

From the fifth century until 1018, Dumbarton was the capital of the ancient kingdom of Strathclyde. The castle has the longest recorded history of any stronghold in Great Britain. In the thirteenth century it was a royal burgh. It made a perfect stronghold, and was a power centre of the Scottish kings, used as a strategic naval base during their long struggle to control the Highland and Hebridean chieftains.

While tourists climb the steps to explore the castle, others choose to go right up the sheer face of the rock. Dumbarton's 70 m (230 ft) high basalt cliffs are a honeypot for climbers, with some superb bouldering and sport climbing. Routes are rated moderate to extreme and in 2006, David MacLeod successfully climbed a route called 'Rhapsody', which was the first to be rated E11, making it the hardest in the world. However you get there, the views from the top are sensational.

The River Leven flows out of Loch Lomond and meets the Clyde at Dumbarton. Denny's Shipyard was founded on the Leven just before the rivers meet, and it became one of the most innovative yards in the world. Denny's built the world's first ship testing tank in 1883, which the firm used to test hull designs and propulsion methods, including propellers, paddles and vane wheels. The yard closed in 1963, but you can still see the tank, as it has been preserved and is part of the Scottish Maritime Museum. *Cutty Sark* was built at Denny's in 1869, and she is now preserved in a dry dock in Greenwich, London.

GREENOCK

The Firth of Clyde has one of the deepest sea entrance channels in northern Europe, allowing it to handle the largest modern vessels. The Clyde is one of the UK's leading ports, handling some 7.5 million tonnes of cargo each year. Much of this freight is handled at the container cranes of Greenock's Ocean Terminal. At Inchgreen is one of the world's largest dry docks, which is 305 m long (1,000 ft) and 44 m (145 ft) wide. Greenock's Great Harbour is one of the three main ports used by the Royal Navy for marine services support. Cruise liners visiting the west of Scotland often call here. Greenock was the birthplace of James Watt, whose advances in steam power helped shaped the modern world around us.

The River Leven meets the Clyde. Denny's yard was towards the right in this picture, Ben Lomond is in the far distance.

GOUROCK

Gourock Outdoor Pool is the oldest heated swimming pool in Scotland, and one of only three still open. Built in 1909, it uses salt water taken from the River Clyde, which is thankfully cleaned and warmed up to 29 degrees.

THE OUTER FIRTH

One of the fingers of water reaching into the mountains from the main firth is Gare Loch. On its eastern shore is the Faslane Naval Base, the home of United Kingdom's Trident nuclear submarines. The loch was the site of a major naval base during the Second World War and there is a Royal Marine training centre at Garelochhead.

There are several islands in the outer Firth of Clyde. Bute has glorious beaches, and the historic buildings of Mount Stuart House and Rothesay Castle. Arran is known as 'Scotland in miniature' for its mix of jagged mountain scenery, beaches and lush farmland. Opposite Great and Little Cumbrae on the mainland is Largs, in our era a much-loved holiday spot, but the site of a fierce battle in 1263 that ushered in the end for the Viking dominion of western Scotland.

WE REACH THE SEA

So, as the drops of rain that fell on the Lowther Hills are finally dispersing into the wider ocean, we have reached

The MS *Queen Elizabeth* visits Greenock's Ocean Terminal.

the end of our journey. And like those drops, the story of the Clyde is the tale of something small grown improbably huge, for we must remember that all the achievements written here concern a mere streamlet in one of the world's smaller countries. The Severn is twice as long as the Clyde, the Rhine is almost ten times its size. There are islands in the mouth of the Amazon that are wider than the Clyde is long, but the world's greatest-ever shipbuilding centre wasn't built on any of them.

Like the hundreds of silvery burns that join at its source, the Clyde's success was made by many factors uniting to create a force greater than the sum of its parts: the natural mineral wealth under its basin; a fortuitous political situation; the rise of an empire; the birth of the industrial world; the drive and genius of its people and a thousand other events that no historian has ever noticed. Its industrial pinnacle has been climbed and such dominance will not be ours again, but it's unlikely to be anyone else's either, and so we have it still.

The river is different today and no doubt it will change again tomorrow. The River Clyde is unique and beautiful, sometimes grumpy, often sad, but always and forever ours.

WALK 7
LANG CRAIGS
DISTANCE: 8 KM
TIME: 2.5 HOURS

Start at Overton House above Milton. Take the tarmac track north through woodland to a gate, and follow signs pointing right to reach the ridge below the crags. After a deer fence you join a very well signposted track, which will guide you all the way back to your start point. You can also pop up Doughnot Hill for even better views of the Clyde as she winds away towards the western sea.

Skipness Castle on Kintyre, with Arran in the background, in the outer firth.

This page: The cragged ridge and hills of Arran, with the ruins of the 13th century St Brendan's Chapel in the foreground.

Opposite: The MS Queen Elizabeth departs from Greenock and heads for the open ocean.

Highland cattle strike their best postcard pose near Ardmore.

MIND THE GAP